T0278164

FARNBOROUGH'S MILITARY HERITAGE

Dean Hollands

AMBERLEY

Historia est vitae magistra.

'History is the tutor of life.'

This book is dedicated to the men and women of Farnborough who have, and who continue to work tirelessly in pursuit of preserving, protecting and promoting the town's heritage, making it visible, accessible and known to all who seek it, and to the future generations who will follow in their footsteps.

Front cover top image: Men and machines of No. 2 Company Aeroplane ABRE, 1915.

Front cover bottom image: Building Q120.

Back cover image: Boer War memorial to unknown soldier.

First published 2021

Amberley Publishing
The Hill, Stroud
Gloucestershire, GL5 4EP

www.amberley-books.com

Copyright © Dean Hollands, 2021

Logo source material courtesy of Gerry van Tonder

The right of Dean Hollands to be identified as the Author of this work has been asserted in accordance with the Copyrights, Designs and Patents Act 1988.

ISBN 978 1 3981 0161 6 (print)
ISBN 978 1 3981 0162 3 (ebook)

All rights reserved. No part of this book may be reprinted or reproduced or utilised in any form or by any electronic, mechanical or other means, now known or hereafter invented, including photocopying and recording, or in any information storage or retrieval system, without the permission in writing from the Publishers.

British Library Cataloguing in Publication Data.
A catalogue record for this book is available from the British Library.

Typesetting by SJmagic DESIGN SERVICES, India.
Printed in Great Britain.

Contents

Foreword

At the turn of the twentieth century Farnborough was a small, quiet town in north-east Hampshire existing in the shadow of the larger and more important army town of Aldershot.

Between 1905/6 the army moved their Balloon Factory and School from Aldershot to South Farnborough and this presaged the beginning of an aviation research establishment destined to become world-famous. Wikipedia notes that 'The town is probably best known for its association with aviation – Farnborough Airshow, Farnborough Aerodrome, Royal Aircraft Establishment, and the Air Accidents Investigation Branch.' This central focus on aviation is well founded, and it's technical and scientific contributions to the history of British and World aviation is generally well documented in the literature and academic papers.

However, as usual, there are many fascinating aspects of Farnborough and its local surrounds that are not general – or even specialist – knowledge and need to be teased out by intricate and time-consuming research. This is even more true for the social links that have arisen during the forming of Farnborough's aviation history. All this is then followed by the delicate task of tying all of this knowledge into a coherent and readable format.

Dean Hollands, a local historian and author, has managed to do this successfully whilst retaining the 'readability' that is important in holding the attention of the reader whilst ensuring that its educational aspects remain. Along with all of its wider benefits, it is a book that local schools could usefully use in their Local History lessons to spark the imagination of their pupils.

This book forms an important part of the gradually expanding history of the district and is full of the interesting links and associations that would rarely be exposed if these types of books, written by local historians – with a deep interest in research and an even deeper interest in interesting and unusual links – were not published.

Thoroughly recommended.

Dr Graham Rood FRAeS

Introduction

The village of Farnborough in Hampshire was founded in Anglo-Saxon times. Mentioned in the Doomsday Book of 1086, it derived its name from the word Fearnbiorginga, meaning village among the ferns on the hill. For almost a millennium the village remained unchanged, except for a steady increase in population that would reach around 500 by the mid-nineteenth century, a century that saw neighbouring Aldershot established as the 'Home of the British Army', the railway arriving at Farnborough, and the village become home to an exiled empress, whose abbey, St Michael's, dominated the skyline for miles.

Despite these changes Farnborough remained a quiet, idyllic and unassuming village, little affected by the social, political and economic influences of the day.

However, the humdrum peace and tranquillity of rural life was lost forever in 1905 with the arrival from Aldershot of the army's Balloon Factory and Balloon Section. In time, their pursuit of aviation saw balloons, man-lifting kites, airships and aeroplanes yield unprecedented technological advancements in aeronautical research, design and production that made them the envy of aviation enthusiasts and military powers worldwide.

This period saw great technological advances in scientific knowledge that transformed the character of warfare on an unimaginable scale. With the creation of the internal combustion engine came the mechanisation of warfare and the industrial-scale destruction of people, property and equipment became a reality.

Responding to these advancements, expedited by the onset of the First World War, the military authorities gradually transformed the Balloon Factory and the Balloon Section into the Royal Aeronautical Establishment and the Royal Air Force.

Today, Farnborough is home of the bi-annual International Airshow and trade exhibition for the world's aerospace and defence industries. Famous as the birthplace of British aviation, it is acknowledged worldwide for its contributions in advancing military and civilian aeronautics and space flight development programmes.

The diverse nature of military heritage found in Farnborough is unlike any other town in Hampshire, reflecting well its incredible historic character. At its heart and bringing history to life are an exceptional collection of historic buildings, memorials, monuments, structures, and sites of military importance. But the real legacy of the town's military heritage is found in its soul – the collective stories, accomplishments, epic endeavours, successes, failures, and sacrifices of its people, which continues to invigorate and inspire new generations of residents and visitors alike.

Such is the extent of Farnborough's military heritage it is not possible to comment or explore any aspect of that heritage in great detail within the pages of this publication.

However, this book provides a concise and informative overview of the important military periods in the town's development, and insights into the lives and achievements of the many people and events that have shaped its remarkable history. This book signposts readers to the key military attractions and locations within the town with the hope that they will be inspired and intrigued to learn more, visit the sites and share their experiences with others.

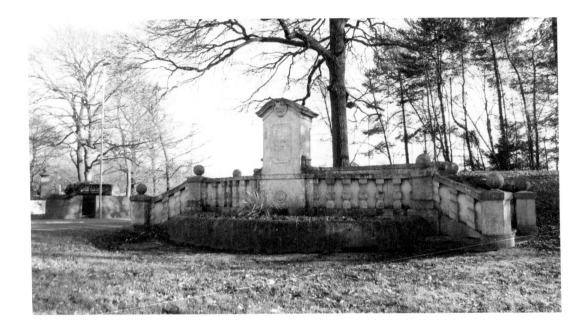

1. Balloon Factory to Royal Aircraft Factory

Farnborough's role in developing civil and military aviation worldwide is undisputed, as is its claim to be the 'birthplace of British aviation'. However, the conception of Britain's military aviation took place thirty years earlier in 1878 at Woolwich, London, when the War Office opened a Balloon Equipment Store. It was from these humble beginnings that the Balloon Factory at Farnborough and its multi-titled successors took root. What follows is the story of the Balloon Factory's arrival at Farnborough and its transformation into the Royal Aircraft Establishment.

In 1854, the War Office bought a large area of land near the village of Aldershot, to build a garrison where the army could train all-year round. The garrison comprised of two camps, one south of the Basingstoke Canal (Aldershot) and the other north of it (Farnborough). Today these villages, now towns, form the borough of Rushmoor.

Following military interest in the use of balloons in warfare, the War Office directed Captain James Lethbridge Brooke Templer, of the King's Royal Rifle Corps, an accomplished free ballooning expert, to design and build a balloon for the army in 1878. Captain Templer built and successfully flew his balloon on 23 August of that year. He was immediately transferred to the Royal Engineers (RE) and directed by the War Office to establish a Balloon Equipment Store at Woolwich, where he was to instruct army officers and Royal Engineers in the art of ballooning.

At Woolwich, balloons were built, flown and experiments undertaken until 1880 when the store was moved to Chatham, Kent. The army continued to build and fly experimental

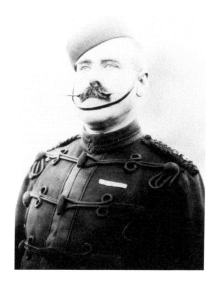

Colonel Templer RE. (FAST)

balloons until 1890, when the Balloon Equipment Store took part in the military's 'Summer Manoeuvres' at Aldershot, conducting balloon reconnaissance for ground forces. Their success resulted in the store relocating to Aldershot, south of the Basingstoke Canal, near the Aldershot Wharf. In 1892 it was reformed as the Balloon Equipment Store and Depot, and the Balloon Section Royal Engineers were established. The Equipment Store developed balloons and provided user instruction, while the Balloon Section flew the balloons.

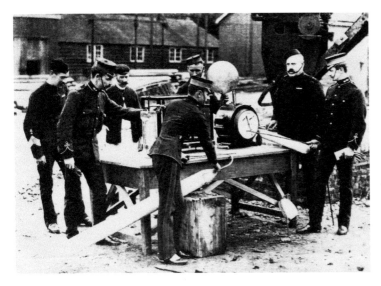

Left: Colonel Templer and men of the Balloon Section Royal Engineers. (AMM)

Below: Men of the Balloon Section Royal Engineers. (AMM)

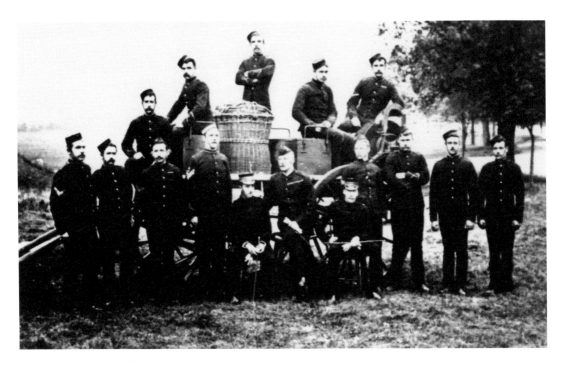

Under the command of Lieutenant Colonel Templer, now 'Instructor of Ballooning', the Balloon Equipment Store was renamed the Balloon Factory in 1897 with Templer as the factory's Superintendent. Developments in science and technology ensured rapid advancements in aviation could take place, allowing the Balloon Factory to include man-lifting kites, airships, balloon winches, signal balloons and photographic equipment.

The 2.5-acre site at Aldershot offered no potential for expansion, so in 1904 the existing balloon shed, gasholder and hydrogen production plant were dismantled and reassembled on a new 22-acre site on the eastern limit of what was then Farnborough Common. In addition, a new airship shed, measuring 60 feet (18 metres) long, 82 feet (25 metres) wide and 72 feet (22 metres) high, was built incorporating new workshops and stores. In order to accommodate future generations of larger airships the shed was doubled in length and widened again in 1912.

The first balloons were tethered on Farnborough Common in 1905 and were flown regularly over the area by the Balloon Section RE. Along with the Balloon Factory, in 1906 came the colourful and charismatic American aviation pioneer Samuel Cody (Cowdery). Cody bore a striking resemblance to his hero, the wild west legend Colonel

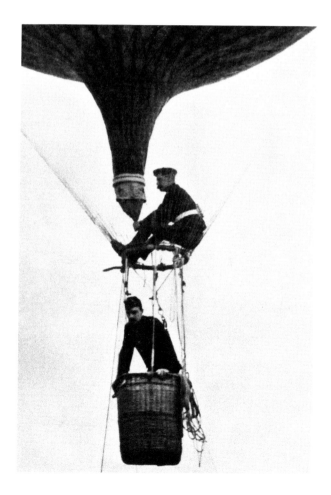

Conducting observations. (AMM)

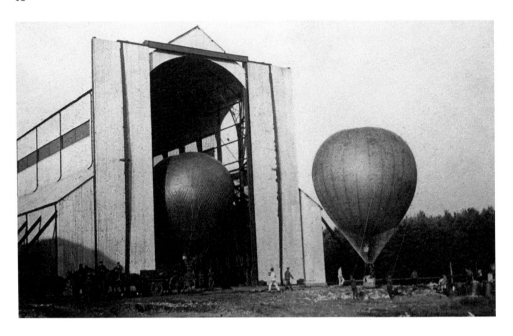

Above: Balloons tethered on Farnborough Common. (FAST)

Left: Samuel Cody.

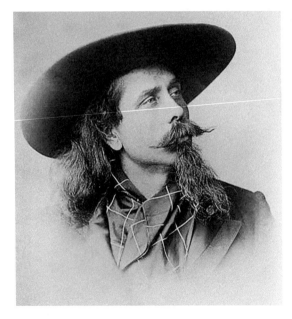

William 'Buffalo Bill' Cody; he even adopted his surname and occasionally his persona, for which William Cody successfully sued him on two occasions. Cody worked in the factory developing and flying man-lifting kites but would later be concerned with airships and aeroplanes.

As the Balloon Factory and Balloon Section RE continued developing, building and testing its balloons, kites, airships, the skies of Farnborough and the landscape below

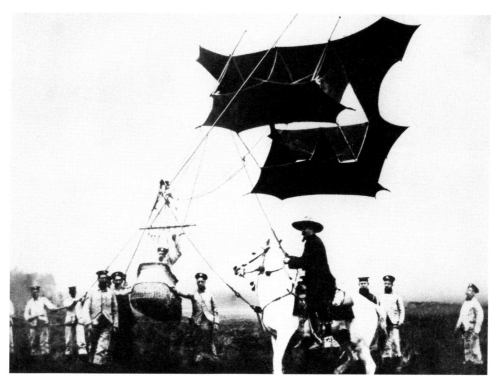

Cody's man-lifting kite. (FAST)

bore witness to many aeronautical achievements and disasters. In 1906 the army extended Cody's role, employing him as 'Chief Kiting Instructor' where he became known as 'Colonel Cody'. Cody was never a soldier in the British or American armies, but adopted the title following a visit to the Balloon Factory by King George V in 1910. Employed by the army, Cody was paid the same rate as his counterpart Colonel Templer, and afforded all the benefits of being an officer, such as membership to the officers' mess. His colleagues jokingly called him 'Captain Cody'. When introduced to the king, the king mistakenly proclaimed to the assembled audience, 'Ah, you must be Colonel Cody!' and from that moment Cody adopted the title stating that if it was good enough for the King to call him colonel, then others should follow suit, and the name stuck.

Balloons and kites provided static aerial reconnaissance in calm conditions and in winds up to 50 mph (80 kph). However, when winds were too strong, Cody's kites were deployed to lift men high into the air. In particular the 'Bat Kite' was more effective than other systems being trialled and could lift observers over 1,000 feet (305 metres) with high levels of stability. Cody's system used a steadying kite, connected to a series of lifting kites which would lift a person. The lifting kites were attached to the main kite cable by towing rings, with the number of lifting kitesdependent upon the wind conditions and load carried.

Once the kite was released, the wind blew it up a cable fitted with a series of cone-shaped stops which became progressively larger towards the top of the cable. The size of the cones corresponded to the size of the towing rings on the kites. As the first lifter kite travelled

Colonel Capper RE. (FAST)

up the cable, its larger towing ring would pass over the smaller cones until it reached its intended anchorage point. At this point the cone was larger in diameter than the towing ring, causing the kite to stop. The next kite, with a smaller towing ring, would travel up the cable, passing over the smaller rings until it reached its anchorage point. This was repeated until the carrier kite attached to a trolley moved up the cable. Suspended from the trolley was a basket which moved up the cable until it reached the lowest lifting kite, where it would stop. Inside the basket a passenger could control the rate of ascent and descent using a system of lines and brakes. Adjusting these lines allowed the basket and passenger to remain horizontal.

Templer remained superintendent of the Balloon Factory and was promoted to full Colonel in 1902. In 1906, he was succeeded by Colonel John Edward Capper RE. This was the year in which the factory became fully operational and Cody was tasked with forming two kite sections of the Royal Engineers. As changes were made to the Balloon Factory's name and role, these kite sections became part of the Air Battalion Royal Engineers, and its successors, No. 1 Squadron, the Royal Flying Corps, and then No. 1 Squadron Royal Air Force.

Cody turned his attention to manned flight, and in addition to working with Capper on building the first military airship, *Nulli Secundus*, he designed a biplane-style glider uniting features from his earlier kites. In one demonstration the glider rose to a height of 100 feet (30 metres) and when released with Cody lying prone on the lower wing, it glided back to earth, covering a distance of over 700 feet (213 metres). Cody also built and successfully tested a motorised kite which he wanted to develop into a man-carrying aeroplane.

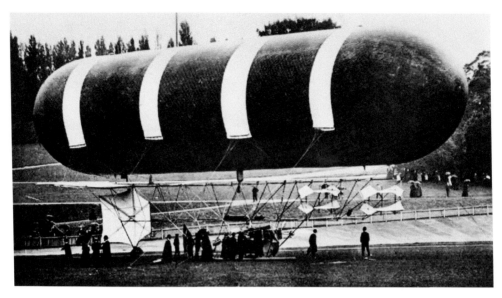

The airship *Nulli Secundus.* (AMM)

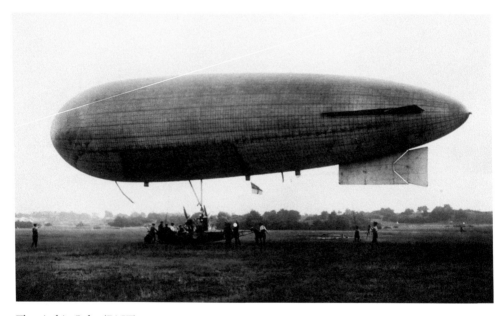

The airship *Baby.* (FAST)

Among them were the Airships *Nulli Secundus, Nulli Secundus II, Baby, Beta,* and *Gamma.* The maiden flight of Britain's first Airship, *Nulli Secundus,* measuring 120 feet (37 metres) in length with a diameter of 26 feet (8 metres), took place on 10 September 1907 when it flew over Farnborough Common. Powered by a 50 horsepower Antoinette engine, it was crewed by Capper, Cody and King. The short flight was followed by two others on 30 September and 3 October. Then on 5 October, it took off for London

piloted by Capper and aided by Cody and Lieutenant C. Waterflow RE. The record flight covered a distance of 40 miles (64 kilometres) and took 3 hours 25 minutes, cruising at a speed of 16 mph (26 kph) at a height of 750 feet (229 metres). The airship passed over Buckingham Palace, the War Office, circling St Paul's Cathedral twice, before attempting a return to Farnborough. However, unfavourable winds forced it to moor at the Crystal Palace, London.

On 1 April 1908, the Balloon Factory was granted royal patronage and renamed 'His Majesty's Balloon Factory'. Cody and Dunne continued testing and modifying their aeroplane designs, each determined to make the first manned flight in Britain. In the summer of 1908, Dunne returned to Blair Atholl with his D.4-powered aeroplane, which would have made the historic flight had it not been underpowered, making it, in Dunne's words, 'more a hopper than a flyer'. The race was eventually won by Cody in the autumn of that year, who on 16 October made the first officially recognised flight of a piloted heavier-than-air machine in Great Britain. Cody flew his machine, the Army Aeroplane No. 1 (Cody 1), for twenty-seven seconds at a height of 30 feet (9 metres), covering a distance of 1,390 feet (423 metres) before crashing into the ground. Cody emerged unscathed from the wreckage an aviation legend, with Farnborough, not Blair Atholl, becoming the birthplace of British aviation.

Flight marker, Farnborough Road.

Replica of Army
Aeroplane No. 1.
(FAST)

Despite further advancements and successes in aeroplane development by Cody and Dunne, in April 1909 the Committee of Imperial Defence produced a report that suggested there was no future for aeroplanes beyond that of sport. They directed military development and experimentation of aeroplanes to be stopped, and airship development to be advanced. As a result, work on balloons was side-lined, and work on aeroplanes ceased in favour of the more popular airships.

Cody remained at the Balloon Factory, which was brought under civilian control. Capper was replaced by Mervyn O'Gorman. O'Gorman was an electrical and aircraft engineer whose appointment signalled the start of a more scientifically focussed approach towards

Lieutenant Colonel Mervyn O'Gorman.

aeronautical research and development at the factory. Dunne left the factory and the army to form his own aviation company – the Blair Atholl Aeroplane Syndicate.

Over the next two years a number of significant events nationally and internationally caused the War Office to review its decision to stop work on powered aircraft. Firstly, in May 1909 the French aviator Louise Bleriot crossed the Channel, unnoticed and uninvited, in just 37 minutes to land at Dover. The following April, the first ever long-distance air race took place from London to Manchester, demonstrating new levels of speed and endurance in aeroplanes.

During the army's annual military manoeuvres on Salisbury Plain in 1910, privately owned aeroplanes loaned to the army successfully demonstrated the first air to ground wireless transmissions at ranges of up to 1 mile away. Their versatility in gathering and communicating information on battlefield activity was proven to the War Office. Ongoing political tensions including the 1908–09 Bosnian annexation crisis, the heightening tension between Germany and France, and evidence of greater speed, distance and endurance displayed by private aeroplanes combined to convince the War Office that aviation could be useful, even necessary in war, and they reversed their decision to end aeroplane experiments.

Britain's political and military leaders perceived they had slipped behind their European neighbours. Realising an urgent need to improve they immediately ordered a major reorganisation of aviation development and production within the British Army.

In December 1910, aviation pioneer and aerospace engineer Geoffrey de Havilland joined HM Balloon Factory and sold them his second aeroplane. This was the machine that he designed, produced and taught himself to fly, and which, in time, would be the first

Geoffrey de Havilland's home in Alexandra Road.

aircraft to bear an official Royal Aircraft Factory designation, FE1. For the next three years de Havilland designed or helped to design a number of experimental types of aeroplanes.

A year later in 1911, the War Office authorised the Balloon Section RE to become an Air Battalion of the Royal Engineers. HM Balloon Factory was renamed the Army Aircraft Factory (AAF) and reconfigured, with its primary focus on producing motorised airships for the army. More departments and posts were added as science and technology continued to drive experiments in aviation.

The AAF was designated the Royal Aircraft Factory (RAF) in 1912, and continued its experimental work developing engines, airships and aeroplanes. The AAF's official remit did not include designing new aircraft, but O'Gorman managed to circumvent this restriction, gaining permission to improve and modify machines that they already possessed, such as de Havilland's FE1, so they could be used for experimentation. This 'sleight of hand' enabled the RAF to create hybrid machines that eventually had little or none of their original features remaining, creating new machines without having official permission.

As the AAF was not intended to be involved in the production of aircraft, its designs were officially classified as 'E' – experimental. They used a prefix of either a famous aviation pioneer or the aircrafts functionality, e.g. AE (Armed Experimental), BE (Bleriot Experimental), BS (Bleriot Scout), CE (Coastal Experimental), FE (Farman Experimental), HRE (Hydroplane Reconnaissance Experimental), NE (Night-flying Experimental), RE (Reconnaissance Experimental), SE (Santos Experimental), and TE (Tatin Experimental).

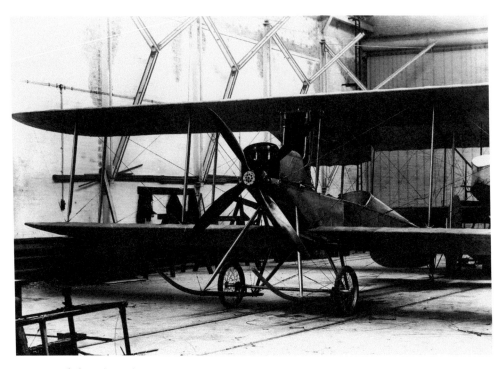

BE1 in workshop. (FAST)

Between 1912 and 1913 the RAF produced the airships Delta, Beta II, Gamma, Gamma II, and Eta, and between 1912 and 1917 the aeroplanes AE1 – 3 / BE2a – BE12b / CE1 / FE1 – FE12 / NE1 / RE1 – RE9 / HRE2 / BS1 – BS2 / SE2 – SE6 and TE1. In addition, the RAF produced fifty different engine variants from the 1913, eight-cylinder air-cooled 90-degree tractor engine to the 1917 two-stroke semi-rotary valve air-cooled head engine.

In 1918, the Royal Air Force was founded, and to avoid any confusion over the shared RAF acronym the Royal Aircraft Factory became the Royal Aircraft Establishment (RAE). Relinquishing its manufacturing role, the RAE focussed research on improving performance, safety and reliability in all aspects of aviation. In addition, they provided specialist training, coupled with professional scientific and engineering qualifications in aeronautics through an apprentice scheme. This transformation heralded the next chapter in Farnborough's aviation history.

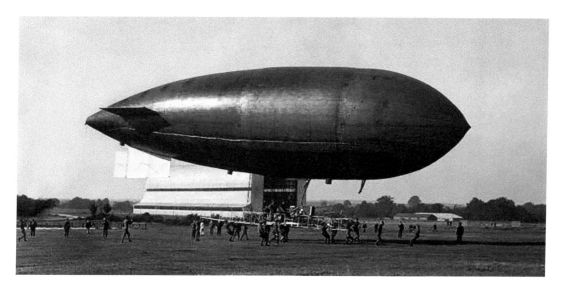

Above: Airship *Beta*. (FAST)

Right: Royal Aircraft Factory, 12-cylinder engine. (FAST)

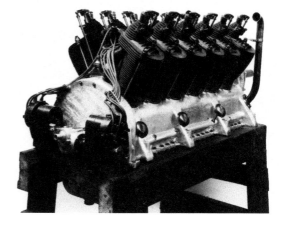

2. Royal Aircraft Establishment to Royal Aerospace Establishment

From its beginning in 1918, the work undertaken at the Royal Aircraft Establishment (RAE) was a mystery to the majority who worked there. Every attempt was made to keep each department's projects secret and the strictest security measures were employed. While more recent events in its history remain classified, much remains to be shared, hitherto unknown except by a small group of knowledgeable enthusiasts and former employees.

In the decades that followed its formation, the RAE developed many expert departments. Specialising in innovation, creativity and invention, it continued to push the boundaries of science and technology to new heights. As a result, many aviation firsts were achieved at Farnborough.

When the First World War ended in 1918, money for defence became scarce, but the RAE survived cuts made to other national facilities. Shifting its focus towards improving performance, safety and reliability, it embarked upon research into almost every aspect of aviation, albeit with a much-reduced budget. Rapid advances in science and technology allowed more complicated aircraft to be designed. However, constructing them would require new specialist skills and training. To achieve this, the RAE developed an apprentice training scheme that enabled trainees to gain professional scientific and engineering qualifications.

Above left: Apprentices and a model Vampire. (FAST)

Above right: Apprentice and workpiece. (FAST)

During the late 1900s, aviation was plagued by aeroplanes losing control in low-speed flight, causing them to spin out of control and crash. During the early 1920s, key scientific principles such as aerofoil and airscrew theories were trialled using large whirling arms, wind tunnels and low-altitude spinning flights. Besides improving safety, the RAE continued to make advances in military aeronautics, with wireless and photographic departments being established in 1920.

Continuing the RAE'S research into aerodynamics, they used wind tunnels extensively. In 1920 the first specialised wind tunnel building was erected containing two 7-foot

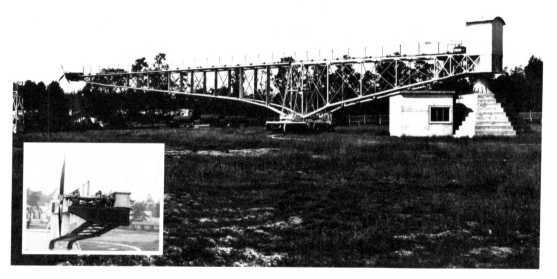

Whirling arm. (FAST)

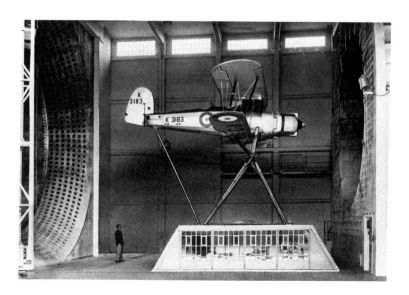

Bristol Bulldog-K3183. (FAST)

(2-metre) tunnels. In 1935 a new, 24-foot (7-metre) large-scale tunnel was built to test engine cooling, and the effects of drag on full-scale aircraft. Further smaller specialist tunnels were added in 1938, 1942 and 1944, and in 1956 a Transonic Tunnel was built to test models at speeds between Mach 0.9 and Mach 1.4. From, the 1950s until its closure in 1993 all major military aircraft projects were tested using these tunnels.

One common safety problem was inflight engine fires, which the RAE researched and tested by setting aircraft alight in mid-air, resulting in the world's first in-flight extinguishing systems being developed in 1923. During trials, the only fatality followed a bad landing in which test pilot G. H. Norman escaped alive, but later died from his injuries. As a result of his death experiments into fireproof fabrics followed, and during this period the gun synchronisation gear was perfected, enabling aircraft to fire through the arc of its spinning propeller without bullets striking its blades. Research into electrically heated flying clothes began and the first hood for 'blind flying' instruction was produced, along with fixed and free camera guns.

In 1924, the first British in-flight refuelling trials were carried out by two Bristol fighter planes over Farnborough using a weighted wire (replaced by a cable and then a hose), which was used to pass water between the two planes. While initial contact was difficult it was deemed achievable, but further trials weren't undertaken until 1930, when several permutations were explored. These included wingtip-to-wingtip, wingtip-to-cockpit and

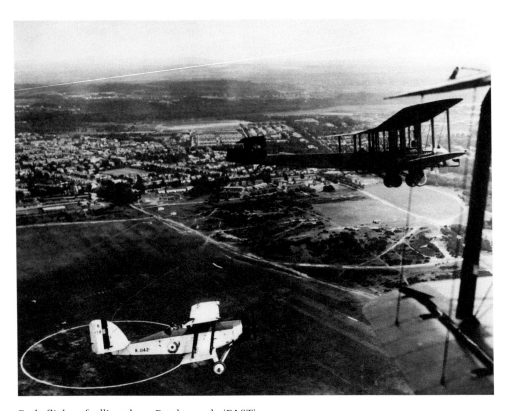

Early flight refuelling above Farnborough. (FAST)

cockpit-to-cockpit and earlier methods that required the observer in the rear gunner seat to catch a hose and haul it onboard.

During 1925, early helicopter designs by inventor Louis Brennan used a small 'car' suspended beneath a single 62-foot (19-metre) rotor blade, with small propellers attached at either end of the blade tip. Despite over 200 test flights it proved too unstable and following a crash due to control system failure in 1926, the project was abandoned. Parallel research into autogyros had been conducted using a Spanish-built Cierva aeroplane. Having removed the wings the fuselage was fitted with a two-bladed rotor, which proved highly successful, becoming the forerunner of today's helicopters.

The development of radio-controlled aircraft was also pioneered at this time. While the first ever radio-controlled pilotless aircraft at Farnborough flew in 1917, it was in 1925 that the RAE developed the Larynx, a 100-mile (160-kilometre) range radio-controlled flying bomb. Although successful, the programme was abandoned in 1929 in favour of the 'Fairy Queen', a pilotless radio-controlled seaplane. It was used as a flying target for the Royal Navy gunnery practice, succeeded in the 1930s by the larger 'Queen Bee' Tiger Moth seaplane, from which today's use of the term 'drone' stems.

By 1930, experiments had been undertaken to develop a compressed air catapult capable of launching aircraft from a launch trolley off the back of ships and from locations where no runway was available. This project culminated in creating the MKIII hydro-pneumatic catapult capable of launching a fully laden heavy bomber up to 65,000 lbs (29,484 kg). Despite its capabilities, with the advent of concrete runways the project was abandoned in 1943.

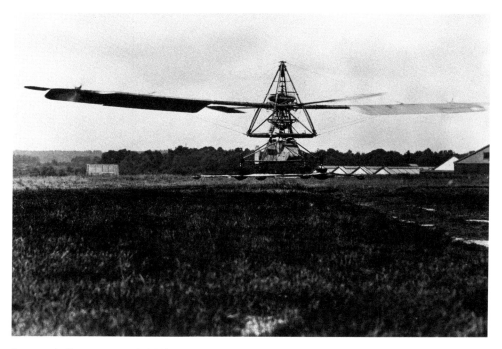

Brennan helicopter, 1925. (FAST)

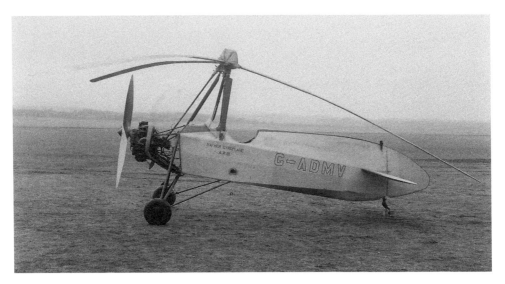

Hafner Gyrocopter G-ADMV. (FAST)

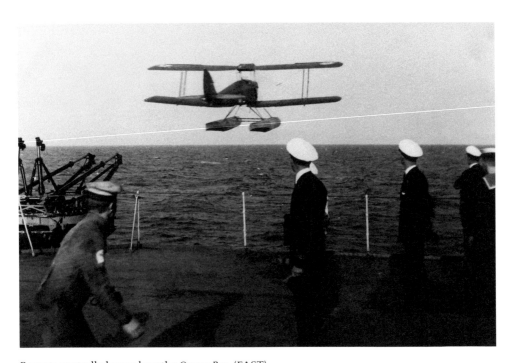

Remote-controlled aeroplane the *Queen Bee*. (FAST)

In 1932, a water tank 650 feet long (198 metres), 9 feet wide (3 metres) and 4.5 feet deep (1.4 metres) was created and fitted with a wave generator to simulate taking off on variable water conditions. To examine how seaplanes and flying boats performed during take-off, landing and slow-speed taxiing, high-speed cameras were used to film scale models being towed down the tank.

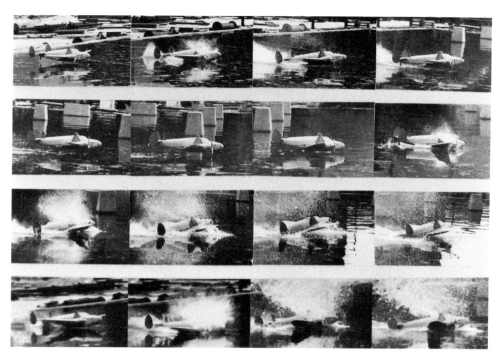

Model Viscount aeroplane, ditching tests/Model Hudson aeroplane, ditching test. (FAST)

During the Second World War, many aircraft returning from bombing operations were damaged or short of fuel, forcing them to land on water – 'ditching'. In 1941 the RAE were tasked with finding the best way to bring a land plane to rest on the water. Prior to 1939 some work had been carried out on ditching using the water tank and towing technique. The shortcomings of this method were soon realised, and recommendations were made that ditching investigations should be undertaken by catapulting free-flight models on to open water. Models were catapulted on to open water and their landings photographed using high-speed cameras. These tests provided more realistic results than the water tank. The tank became redundant in the late 1950s and was demolished in 2005 – a small 20-foot (6-metre) section remains today within the business park and now forms part of a water feature.

Between the two world wars, the RAE was responsible for the reconstruction of the RAF's system of radio communications. All ground stations were re-equipped by 1934 and short-range telephony systems were fitted to combat aircraft, followed by VHF equipment.

High-altitude experiments began in 1936 to examine the problems experienced by aircraft, engines and pilots in thinner air. A world altitude record was achieved in September that year by Squadron leader F. R. D. Swain ascending to 49,967 feet (15,230 metres). In June the following year that record was broken by Flight Lieutenant M. J. Adam, who reached 53,937 feet (16,440 metres). Adam was tragically killed three months later during a routine flight, crashing into Cove Reservoir after taking off from Farnborough.

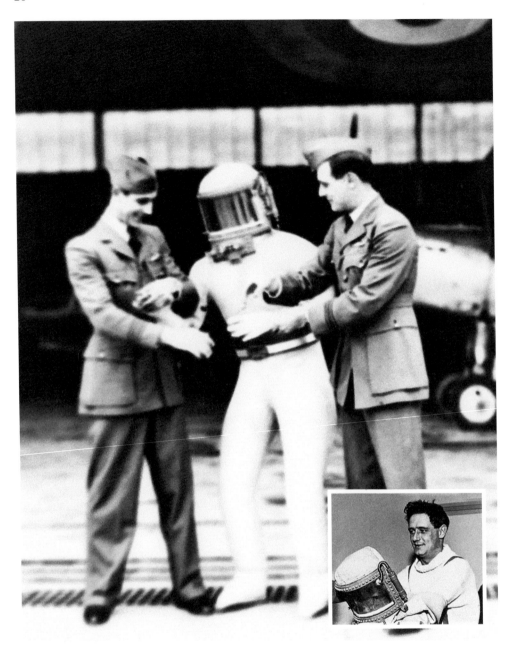

Flight Lieutenant M. J. Adam – high-altitude pressure suit. (FAST)

To achieve these feats, the RAE adapted engine designs and developed more sophisticated propeller shapes, oxygen systems and heated pressurised flight suits for pilots. High-pressure altitude chambers were used from 1939 in the RAE Physiology Laboratory. Throughout the Second World War the RAE continued experimenting with pressure suits during high-flying reconnaissance operations. In time post-war research

into ultra-high-altitude pressurised suits contributed to the development of suits used in space capsule flights.

During the late 1930s the RAE conducted one of aviation's first attempts at controlling the weather on Laffan's Plain. Code-named 'Fog Intensive Disposal Of' (FIDO), experiments were undertaken using large oil burners placed alongside the runway to disperse fog. The research was renamed 'Fog Investigation Dispersal Operations' and following the outbreak of the Second World War, the outcome of these trials became important to Britain's ability to conduct sustained operations against Germany.

Fog was responsible for the loss of large numbers of RAF aircraft and personnel returning from night-time operations over Germany. At night it often obscured large areas of the ground, making it difficult for pilots to see airfields and runways, and when pilots couldn't see to land, to save lives, they would fly their planes towards the sea and bail the crew out by parachute, leaving the aircraft to crash. When operations involved several hundred aircraft, significant numbers of planes were lost in this way.

Trials of FIDO ended successfully in 1942, when before an incoming aircraft arrived, two lines of pipes, fitted with burner jets at regular intervals and supplied with kerosene, running along either side of a runway, were lit. Flames from the pipes burnt fiercely, and the heat generated cleared an area of dense fog 150 feet (46 metres) long and 80 feet (24 metres) high in minutes. Larger-scale FIDO systems were introduced that routinely cleared fog to a height of several hundred feet allowing the approaching pilots to see the glow of the burners hundreds of miles away.

Other wartime innovations developed at Farnborough included research into the detonation of magnetic sea mines by giant airborne magnets. Trials began in 1939 and resulted in creating large electromagnetic rings 48 feet (15 metres) in diameter being fitted to the fuselage and wingsof Vickers Wellington aircraft. The secret and sensitive nature of the work undertaken at the RAE generated fears of military espionage and great lengths were taken to ensure that information was not leaked or removed from the establishment. The integrity of staff was regularly tested. For these reasons it came

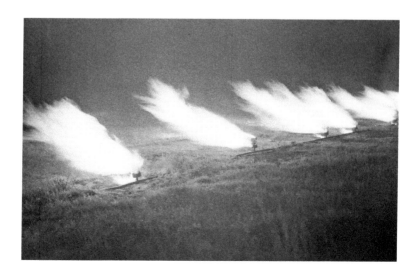

Fog dispersal apparatus on airfield at night. (FAST)

as a great shock to all at the RAE when former Royal Flying Corps (RFC) and Royal Air Force (RAF) veteran Wing Commander Richard Blomfield DSO was accused of spying. Blomfield, who had previously served at Farnborough, and with distinction in France during the First World War, had rejoined the RAF as a recruitment officer at Farnborough in late 1939. He was arrested in January 1940, following an investigation into a report that he had unlawfully passed classified information to a third party. The Judge Advocate General charged him with the military offence of 'conduct to the prejudice of good order and Air Force discipline in relation to unlawfully sharing classified information'.

Wing Commander Blomfield was sent for court-martial in March 1940. The evidence showed that on 17 of January 1940, he had written a letter on official-headed paper to a friend he'd met during a secondment to the United States, Mr Wallace Groves, of New York. Within the letter, he informed his friend of the following: 'We are testing out a plane here with super magnets in the wings and it flies low over the sea and up comes the magnetic mines to the surface. It is proving very successful and I am telling you privately as I know the idea would appeal to you. You fly as low as you and I were taken over the water from Miami to your island.'

The device being referred to was 'Directional Wireless Installation'. This was an electromagnetic hoop installed on a British Vickers Wellington twin-engine, long-range medium bomber. The letter, written in his hand and on RAF-headed paper, was discovered during routine work by the Ministry of Information's Censorship Department. Before the conclusion of his trial on 16 March 1940 he was found dead by his Batman in the kitchen of his home in Alexandra Road, Farnborough. He'd killed himself, never knowing that the court had found him guilty of the lesser civil offence of communicating classified information to a foreign national and were deliberating his sentence. He was buried with full military honours in Aldershot Military Cemetery.

During the First World War the RAE developed aerial photography and designed cameras capable of taking multiple images in quick succession, enabling maps of entire battlefields to be produced. In the Second World War reconnaissance cameras were further developed creating the Williamson F.24 roll film reconnaissance camera. This could be mounted in the wings of a Spitfire for low-level vertical imagery or in the rear fuselage for vertical and oblique imagery. The camera was also used by Bomber Command for undertaking bomb-damage assessment.

To increase hit rates during combat, RAE scientist Leslie Bennet Craigie Cunningham researched gyro mechanisms to improve gun aiming. He successfully developed the 'Gyro Gunsight', a modification of the non-magnifying reflector sight, in which the amount of aim-off in front of a moving target and bullet drop were calculated automatically, creating increases in hit rates. At the same time the RAE produced the Stabilized Automatic Bomb Sight (Blackett Sight), which was a development of the Course Setting Bomb Sight, first introduced in 1917.

During the Second World War the RAE were responsible for evaluating the performance of captured German aircraft, which by the end of the war came to over sixty. These were test flown by the RAE's Chief Test Pilot, Lieutenant Eric 'Winkle' Brown, and his team, nicknamed 'The Rafwaffe'. In addition to intact enemy aircraft, captured German equipment was examined and re-engineered by the RAE. A captured radar set resulted

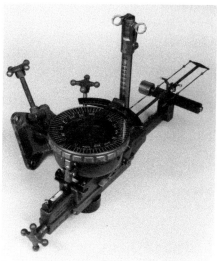

Above left: Gyro Gunsight. (FAST)

Above right: Course Setting Bomb Sight Mk1A. (FAST)

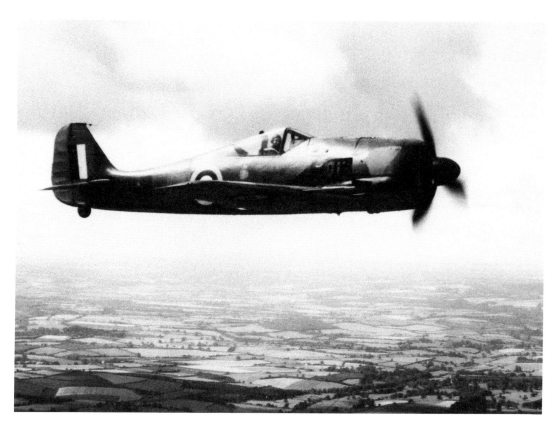

Focke-Wulf Fw 190 Wurger, in British markings. (FAST)

in developments being made that enabled German radar to be jammed during D-Day. The war years also saw the RAE experimenting with camouflage for aircraft, airfields, vehicles, buildings, tents and ships in their various environments.

In 1944, 2 tons of pieces from a German V-2 rocket, which had disintegrated in the air over Sweden, arrived at Farnborough for the RAE to reconstruct, analyse and determine its design and performance. In the same month, the remains of a V-1 flying bomb arrived at the establishment and within three weeks a replica of the impulse motor had been made. This development enabled fighter pilots to successfully knock the V-1 out the sky, avoiding the associated dangers of exploding them mid-air.

Another important activity undertaken by the RAE was investigating physiological conditions of aircrew during high-altitude flying. Initial experiments used a decompression chamber to simulate conditions in which volunteers were filmed attempting to perform various tasks. Within the laboratory, emergency procedures for surviving the loss of pressurisation were tested along with the effects of heated flying suits.

In 1957, a centrifuge fitted with a 60-foot (18-metre) whirling arm capable of rotating up to speeds of 55 rpm and simulating high 'G Force' was commissioned to establish when a pilot would pass out during extreme manoeuvres. The results of the tests allowed flying suits to be designed that enabled pilots to undertake high 'G flying' in modern jet aircraft.

The ejector seat was also invented at this time, and research conducted into safety of materials began with the development of more fire-resistant fabrics and paints, and rust preventatives and corrosion inhibitors for naval aircraft and equipment. The RAE also conducted pioneering work during the 1950s, developing lightweight alloys and composite materials, resulting in the first production of carbon fibre.

Making naval flying safer, the RAE designed and tested angled decks for take-off on aircraft carriers, and the use of an 'arresting gear' to decelerate returning aircraft. Additionally, they developed safety systems such as the Air Position Indicator, an electromechanical system that used airspeed sensors and gyro magnetic compasses to enable a pilot to return to their aircraft carrier unsighted at night or during overcast conditions. In addition to evaluating ditching characteristics of aircraft, trials of survival

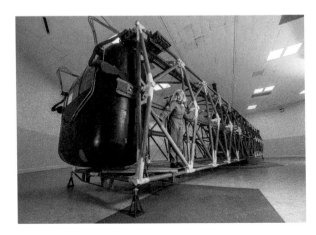

Centrifuge whirling arm. (FAST)

equipment, aircrew floatation gear, inflatable life rafts and air-droppable lifeboats were also undertaken in the water tanks.

The concept and term 'Head-Up Displays' (HUDs), a transparent display in the cockpit that provides a seamless view of critical flight information without requiring users to look away from their usual viewpoints, was developed at the RAE. Built initially

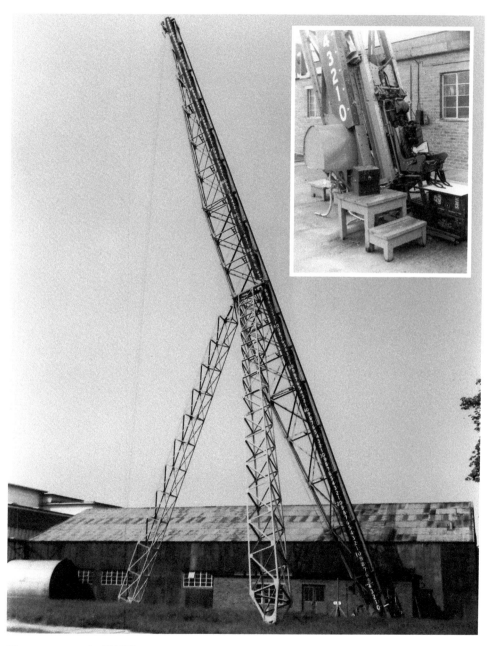

Ejector seat test rig. (FAST)

for military aviation, HUDs is now used in commercial aircraft, and cars. Further development led to helmet-mounted sights where information is displayed on the visor. Night-vision goggles technology was also developed, and flight tested at Farnborough on a variety of aircraft.

In the nuclear age and Cold War period, RAE's expertise was utilised to create solutions to challenges posed by air-launched nuclear weapons. This included safe weapons handling and storage, and the safe arming of aircraft and nuclear weapons. The RAE was also involved in the development of Britain's three V-bombers – the Vickers Valiant, Avro Vulcan and Handley Page Victor – and provided technical direction of the first generation of tri-service surface-to-air guided missile systems – 'Fireflash', 'Sea Slug', 'Bloodhound' and 'Thunderbird'.

Reflecting the increased breadth of the research and development being undertaken by the RAE it was renamed the Royal Aerospace Establishment in 1988. By 1991 however, it had ceased to exist, being amalgamated, with the Admiralty Research Establishment, the Royal Armament Research and Development Establishment and the Royal Signals and Radar Establishment, to form the Defence Research Agency. Today the legacy of the RAE thrives and lives on through Farnborough's College of Technology, among the former sites many listed buildings and within the Farnborough Air Sciences Trust (FAST) museum, where much of its history and heritage can be seen.

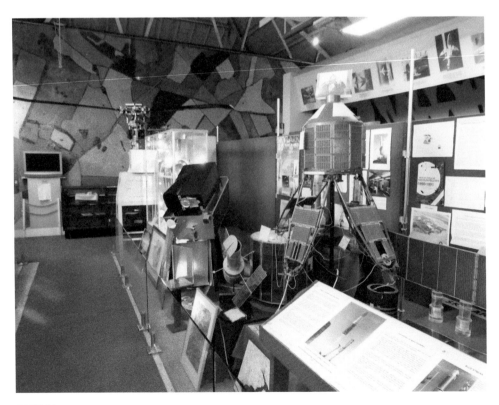

FAST Museum.

3. Sappers and Brylcreem Boys

Following the arrival of the army at Aldershot in 1854, the sight of military personnel around South Farnborough (modern North Camp) was a regular occurrence, as soldiers were billeted first in canvas bell tents, then wooden huts and finally in today's brick barracks. Before work began constructing North Camp the first soldiers of the day to visit these areas were the men of the Corps of Royal Engineers (RE), who surveyed, plotted and planned the new camp layouts and established where key amenities would be located.

Direct descendants of William the Conqueror's military engineers, the RE have served in every major conflict the British Army has fought and lives up to its motto 'Ubique' (Everywhere). In 1856, the Corps of Royal Sappers and Miners were amalgamated with the Corps of Royal Engineers; the rank of 'Private' in the newly formed Corps was changed to 'Sapper', which remains in use today.

The RE's interest in aeronautics began during the 1860s when they explored the possibilities of using tethered balloons for aerial observation. At that time other nations were weaponizing balloons for bombing military targets, sending communications and for transporting personnel, mail and equipment over difficult terrain.

Following their arrival from Aldershot in 1905, the RE became the first military unit to be stationed at Farnborough and brought with them the Balloon Factory and

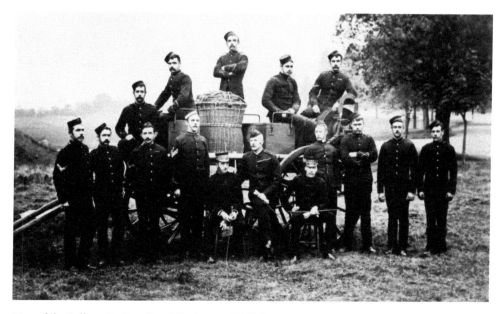

Men of the Balloon Section Royal Engineers. (AMM)

Balloon Section RE. Balloons were first deployed by the RE during the First Boer War in 1885 during expeditions to Bechuanaland and Suakin to spot troop movements, and again during the Second Boer War 1899–1902, to direct artillery fire at the Siege of Ladysmith and Battle of Magersfontein. By the time the Balloon Factory and the Balloon Section RE arrived at Farnborough, they were experienced in the art of using tethered balloons.

The Balloon Factory had developed several spherical and elongated styles of balloon, which were flown regularly over Laffan's Plain and Cove Common. In addition, they were experimenting with motorised balloons, airships, aerial photography, wireless communication and aerial signalling devices.

During the first two decades of the twentieth century military aviation changed dramatically, resulting in a new service being added to the British Armed Forces, the Royal Air Force. The first major transformation was the creation of the Air Battalion Royal Engineers (ABRE) on 1 April 1911. The ABRE were the first flying unit of the British Armed Forces to make use of heavier-than-air- aircraft (airships and aeroplanes). The battalion's regulations stated, it was to be a unit of the Corps of Royal Engineers, and staffed by officers and men of that corps. The new unit's function was to create a body of expert airmen, capable of providing training and instruction in handling kites, balloons, aeroplanes and other forms of aircraft.

The original formation consisted of two companies consisting of fourteen officers and 150 other ranks. Officers could be selected to join the Air Battalion from any branch of the service. To be a pilot, an officer had to have already earned a Royal Aero Club aviators certificate from a private flying school and in addition to being medically fit with good eyesight and previous experience of aeronautics. He had to be unmarried, under thirty years of age, hold the rank of Captain or below, have a minimum of two years' service,

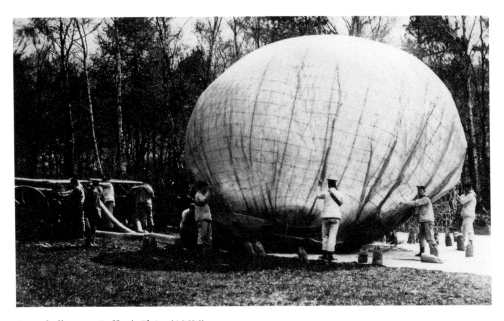

Army balloon on Laffan's Plain. (AMM)

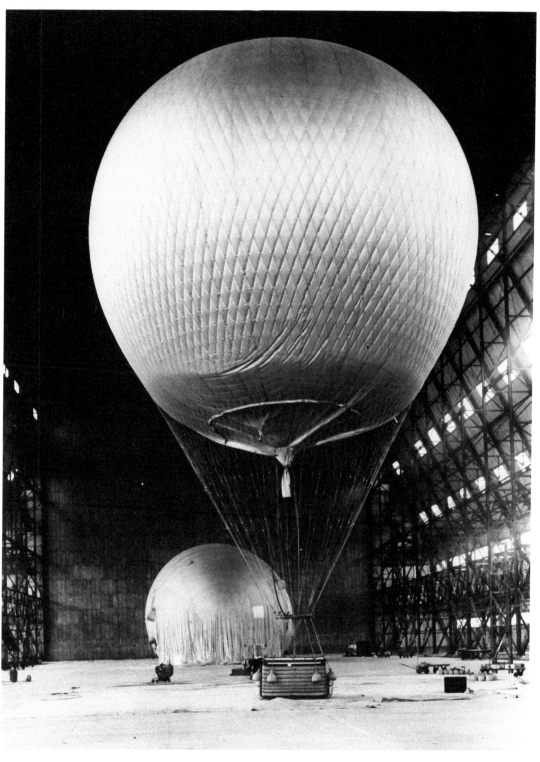

Army balloons at Farnborough. (FAST)

be recommended by his commanding officer, be a good map reader and field sketcher, have knowledge of foreign languages, an interest in mechanics and be under 11 stone 7 pounds. All other ranks selected for the ABRE were existing Royal Engineers who had experience of aeronautics, good map-reading and field-sketching skills, a minimum of two years' service and a good aptitude for mechanics.

The ABRE was formed at the Balloon Factory, Farnborough, and located its headquarters there. Two companies were formed under the command of Major Sir Alexander Bannerman. No. 1 Company, which was equipped with airships, was stationed at Farnborough under the command of experienced balloonist and airship pioneer

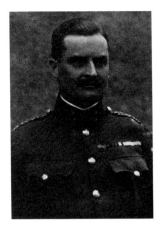

Left: Major Sir Alexander Bannerman.

Below: Men of No. 1 Company Airship ABRE. (AMM)

Captain Edward Maitland RE. He also assisted with the development of parachutes for balloonists, making the first parachute jump from an airship above Farnborough in 1913. No. 2 Company was equipped with aeroplanes and stationed at Larkhill aerodrome under the command of Captain John Fulton, a mechanical engineer from the Royal Field Artillery. Fulton was one of the earliest pilots to be awarded his certificate, number 27, on 15 November 1910.

The ABRE remained in service until April 1912, when, following Italy's use of aircraft in combat against the Ottoman Empire at Tripoli, Libya, the British Imperial Defence staff recommended the formation of a new flying arm with separate military and naval wings. On 13 April, the Royal Flying Corps (RFC) was founded by King George V, which absorbed the navy's Naval Air Detachment and the army's ABRE; Lieutenant General Sir David Henderson KCB, KCVO, DSO was appointed as its Commanding Officer.

Above: Men of No. 2 Company Aeroplane ABRE. (AMM)

Right: Lieutenant General Sir David Henderson.

The RFC consisted of four institutions: the Royal Aircraft Factory and a Military Wing, both administered by the War Office; a Naval Wing administered by the Admiralty; and a Central Flying School under joint administration for use by personnel from both wings. On 1 July 1914 the Naval Wing separated to form the Royal Naval Air Service (RNAS).

The Military Wing of the RFC was formed at Farnborough under the command of Major F. Sykes and initially consisted of a headquarters and three squadrons. They were as follows: No. 1 Squadron formed from No. 1 Company of the ABRE, which remained an airship company; No. 2 Squadron became a new aeroplane squadron created from aeroplane pilots at Farnborough; and No. 3 Squadron, created from No. 2 Company of the Air Battalion. No. 4 squadron was added in August 1912, followed by No. 5 in July 1913, No. 6 in January 1914, and No. 7 in September 1915.

Initially the Military Wing consisted of officers and men who'd transferred from the army, either permanently, on secondment or on temporary attachment. Officers could enter the RFC in two ways, either by transfer from an army unit or, as a civilian joining the Special Reserve of Officers. In time it became possible to join the Military Wing directly as temporary 2nd Lieutenant or Probationary 2nd Lieutenant, being trained at the Recruits Depot Farnborough.

Once direct entry officers resigned their commission and left the RFC, they had to return to civilian life. Officers who had transferred could return to their parent unit and continue their service in the army. All other ranks (warrant officers, non-commissioned officers and privates) were initially transferred from army units and could apply to be a pilot, under the same requirements as officers. Later the exigences of war necessitated recruits joining by direct entry.

With war declared against Germany, Lieutenant-Colonel Hugh Trenchard (who would become known as the 'Father' of the Royal Air Force) was appointed Commanding Officer of the Military Wing on 7 August 1914. With Trenchard now

Marshall of the Royal Air Force, Lord Trenchard GCB, OM, GCVO, DSO. (FAST)

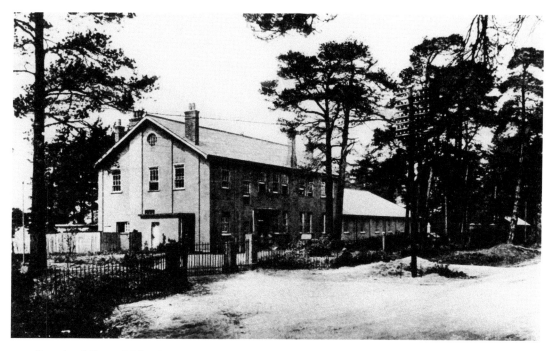

Trenchard House RFC HQ.

in charge of the RFC home garrison and one third of the RFC total strength, he immediately began organising training for recruits and equipping the new units in readiness for service in France. Trenchard made his HQ in the former Balloon School headquarters. Today it is the administrative headquarters of the Farnborough Air Sciences Trust (FAST) and the home of the Farnborough Air Sciences Museum and known as Trenchard House.

Between 1914 and 1918 the use of aeroplanes had developed from unarmed reconnaissance missions to the attacking ground troops, and the bombing of distant enemy cities and military installations. This evolution reinforced the importance of air power and the belief that controlling the skies was a vital part of controlling the battlefield and taking the fight to the enemy. Recognising and acknowledging this importance, a new branch of the military was created on 1 April 1918, when the RFC and the RNAS were amalgamated to create the Royal Air Force (RAF), the world's first independent Air Force under the control of the British government's Air Ministry.

The khaki uniforms of the Royal Engineers and the RFC that were once so prominently seen around Farnborough were replaced with the blue/grey uniform of the men, and in time women, of the RAF who continued to be based at Farnborough in the years that followed. A khaki presence remained at Pinehurst Barracks, north of the RAE running in a curve from the A325 to Pinehurst Cottages along the line of the original Pinehurst Avenue. This camp was mainly wooden huts with brick-built buildings being added later. In 1933 it was renamed Elles Barracks in honour of General Sir Hugh Jamieson Elles KCB KCMG KCVO DSO (1880–1945), who during the First World War was the first

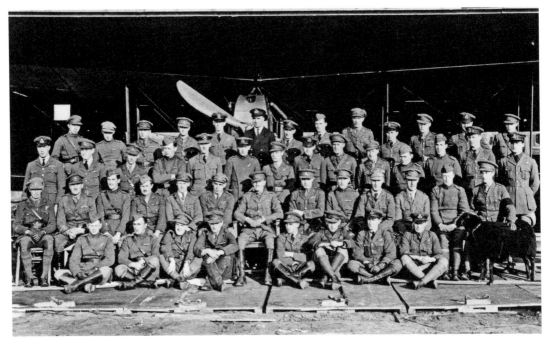

Men and officers of the RFC and RNAS at Farnborough. (AMM)

commander of the newly formed Tank Corps. The 2nd Battalion Royal Tank Corps were stationed there from 1921–39, the Mechanical Warfare Experimental Establishment joined the barracks in 1928, the 4th Battalion Royal Tanks Corps served from 1937–39 and the 55th Army Training Regiment, Royal Armoured Corps were in barracks from 1940.

During the 1970s, most of the barracks was demolished to make way for new town developments. Rushmoor Borough Council offices replaced the Officers' Mess. The Sergeants' Mess remained until 2018 as Elles Hall Community Centre, now awaiting demolition as part of the town's Civic Quarter redevelopment programme.

When war broke out in 1939, the pilots of the RAF came mainly from the upper and middle classes and were seen as 'knights of the air', brave, dashing, smart, always well-groomed and sporting the latest fashion in moustaches and haircuts. Their slick images were used on advertisements by a well-known hair product company of the day called 'Brylcreem', resulting in members of the RAF becoming universally known among the other services and civilians alike as the 'Brylcreem Boys'.

Following the Second World War, Farnborough retained a large military presence which has all but disappeared today. Among the units serving at Elles Barracks were the third training Battalion Royal Army Service Corps and 216 (Parachute) Squadron Royal Signals, the latter relocating to Aldershot on 1 February 1965. At Cove, Southwood Barracks became home to a series of Royal Engineer training regiments, initially for sappers during national service 1947–63 and until the mid-1970s, when training was transferred to Gibraltar Barracks, Blackwater, Camberley. While evidence of the sappers' presence can still be found on the military training areas that remain, most of the site was redeveloped into a housing estate built during the 1980s.

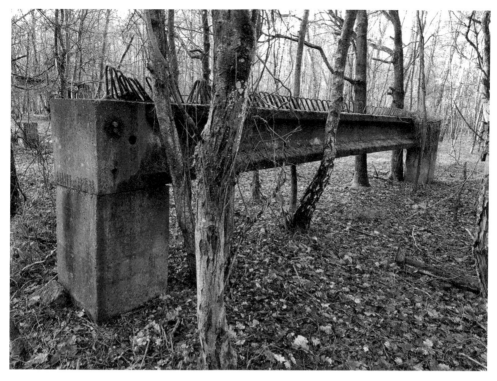

Remains of training facilities at Southwood. (HN)

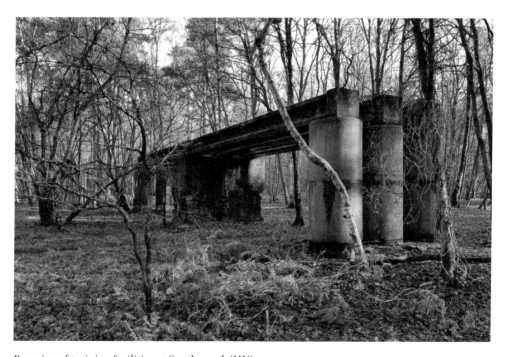

Remains of training facilities at Southwood. (HN)

4. Buildings and Structures

Within the eight wards that make up the borough of Farnborough are a collection of buildings and structures that reflect the breadth and diversity of the town's military heritage. Among them are the remnants of a network of small concrete and brick bunkers, built between 1940 and 1941 as part of Britain's anti-invasion preparations. The most common of these defensive structures were pillboxes, with 28,000 being constructed nationwide. They were built for a variety of purposes at important locations along roads, railways, waterways, beaches and airfields. Today fewer than 6,000 remain and in Farnborough three pillboxes that once formed the outer ring of defences of Aldershot Garrison can be seen.

At Cove, a type 22 pillbox defended the Fleet to Farnborough road, the four-track main London to Bournemouth railway line and the old road that once ran to Pyestock and the Royal Aeronautical Establishment (RAE). The pillbox retains several of its metal loophole flaps and the original turfed roof. Closer to the town, amongst the allotments

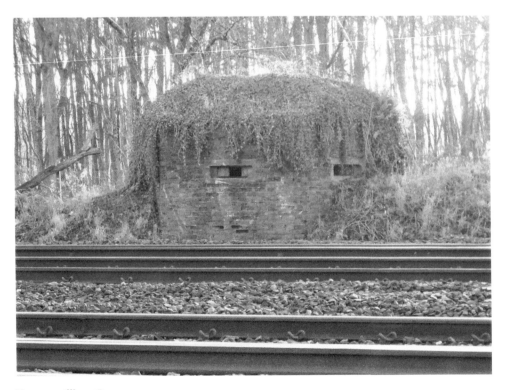

Type 22 pillbox, Cove.

Type 24 pillbox, Coleford Bridge Road.

at Cove, is a type 24 pillbox that protected the railway bridge at the junction of Prospect Road and Union Street. The third pillbox, also a type 24 with metal shutters, is concealed beside the Coleford Bridge Road bridge, and the Guildford to Reading railway line. Two further pillboxes, one at North Camp station and another at West Heath roundabout, once defended the railway but were demolished in the 1960s and '80s, respectively.

A collection of large, enigmatic buildings which give little outward clue to their original function stand within the RAE Heritage Quarter, Farnborough Business Park. The most iconic structure is Britain's oldest airship hangar. This was constructed in 1912 at a cost of £850 and consists of 112 riveted lattice frames, each weighing half a ton, and bolted together to form the 260-foot (80-metre) long structure. Originally covered with canvas, the hangar was designed to be portable so it could be deployed alongside an airship in the field.

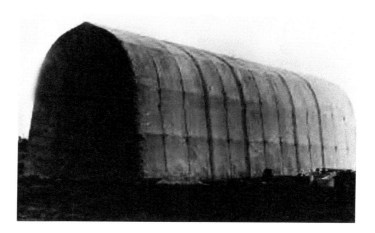

Portable airship hangar frame, 1912. (FAST)

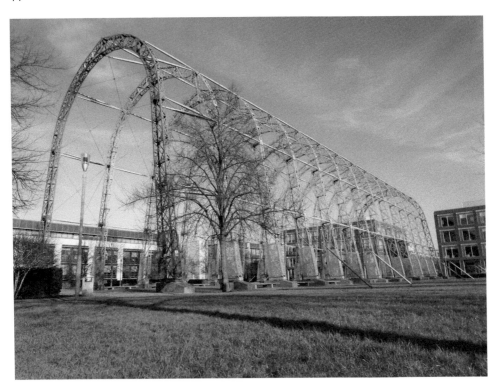

Portable airship hangar frame.

With space becoming a premium at Farnborough the hangar was moved to Tidworth, Wiltshire, in 1913 for further testing. However, later that month the army's airship squadron was suspended from service and testing was abandoned. In November the hangar was dismantled, returned to Farnborough and placed in storage. During 1914 the upper parts were used to erect building R51, a forge and foundry, while the lower sections were used in 1916 to construct building Q65, a fabric workshop.

Other iconic structures include building Q134, the RAE's former Weapons Testing Building and birthplace of the Black Arrow and Black Knight rocket systems. This is now a heritage centre that houses, commercial businesses, the Aviator Café, and the National Aerospace Library.

Several wind tunnels are also located in this area. Britain's largest is in building Q121, a low-speed wind tunnel constructed during the early 1930s and fitted with a fan 24 feet (7.3 metres) in diameter capable of revolving 250 times per minute. The tunnel was used to test the aerodynamic efficiency of full-scale propellers, cooling on air- and liquid-cooled engines, and the impact and effect of air upon different sections of an aircraft to reduce drag. In 1938 a 11.5-foot by 8.5-foot (3.5-metre by 2.3-metre) tunnel was added alongside the Transonic Tunnel R133. Among the many iconic aircraft tested in these tunnels were the Spitfire and Concorde.

Building R136 houses a 11.5-foot (3.5-metre) low-speed wind tunnel and inside building R133 is an 8-foot by 6-foot (2.4-metre by 1.8-metre) Transonic (just below, or just above the speed of sound) wind tunnel. This tunnel tested aircraft at speeds between

Building Q134.

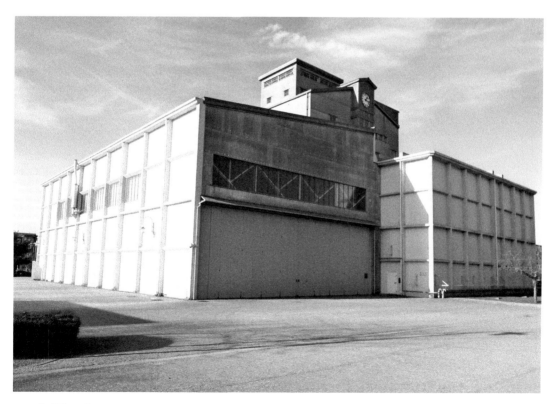

Building Q121.

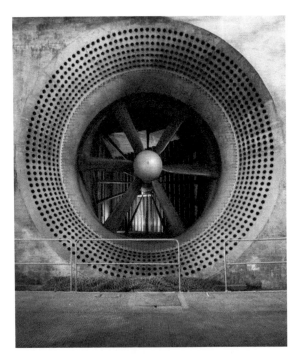

Left: Twenty-four-foot fan inside building Q121.

Below: Five-foot open jet wind tunnel.

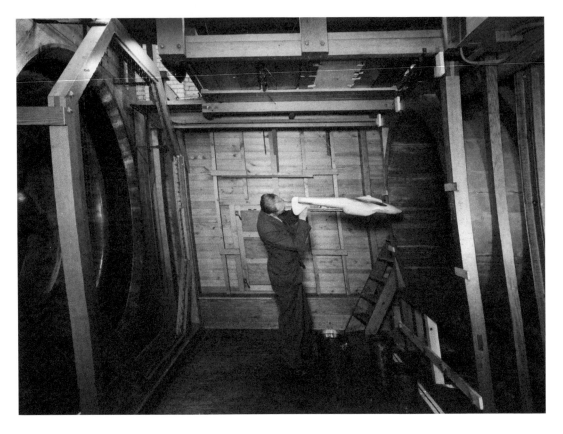

Building R136.

Building R133.

Mach 0.9 to Mach 1.15. It also housed a smaller 2-foot by 1.5-foot (0.7-metre by 0.5-metre) bypass tunnel that enabled models to be tested at speeds of up to Mach 1.4. The tunnels were used to test Britain's first jet engine, and until it closed in 1993 all military jet aircraft projects were tested here.

Building R52, built in 1916, originally housed Britain's oldest wind tunnels, two 7-foot by 10-foot (2.1-metre by 3-metre) low-speed tunnels later developed to house 4-foot by 3-foot (1.2-metre by 1-metre) low-turbulence wind tunnel. Their construction came at a key period for Britain during the First World War. Public criticism about the vulnerability of the Royal Aircraft Factory (RAF) BE2c fighter resulted in Farnborough ceasing to be a site for the state manufacture of military planes. However, the wind tunnels enabled the RAF to make advances in aerodynamics and to understand the impact of airflow on planes in flight. Included amongst their secret experiments was the streamlining of the Supermarine's single-engine, single-seat, high-speed seaplane, the streamlining of bomb shapes and their release characteristics and, for the first time in Britain, supersonic tests with high-speed aerofoils.

The tunnels were used for a wide range of aeronautical research and experiments relevant to military and civil aviation. As well as testing airflow on aircraft and engines, they were used to perform aerodynamic and safety evaluation studies on a wide range of objects. These included the release characteristics of the atomic bomb, and flight characteristics of delta-winged aircraft, resulting in the development of the Vulcan bomber and Concorde. Sir Malcolm Campbell's record-breaking speedboat Bluebird was also tested.

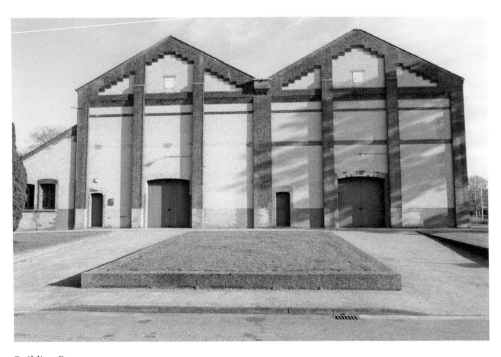

Building R52.

The Seaplane Testing Tank building Q120 is also intact. Opened in 1932, it was designed to test the hulls of new seaplanes and flying boats. High-speed cameras recorded the passage of model planes through the water along the 660-foot (201-metre) tank to examine how they performed during take-off, landing and slow-speed taxiing manoeuvres.

Building G29, known as the 'Black Shed' is unmissable, but not accessible to the public. This imposing building was the first purpose-built aircraft hangar in the country and is the sole survivor of an extensive group of hangars built on the site in 1912. The large timber-framed, iron-clad building was first used by the army's Air Battalion Royal Engineers, then the Royal Flying Corp and finally the Royal Air Force and remains one of only two aircraft hangars in Britain that predate the First World War. The other is at Larkhill, Wiltshire.

Set back from the 'Black Shed' on the Farnborough road is one of the oldest aviation-related buildings in the country, Building G1, Trenchard House, built in 1907 by the Royal Engineers. It became the headquarters of their No. 1 (Airship) Company, Balloon School and then, the temporary headquarters of Lord Trenchard when he was appointed Commander of the Military Wing of the Royal Flying Corps. Today the building is the museum and administrative headquarters of the Farnborough Air Sciences Trust (FAST), and contains a collection of aircraft (actual and model), satellites, simulators, wind tunnel and Royal Aircraft Establishment (RAE) related material and other exhibits that tell the story of Farnborough's aviation history.

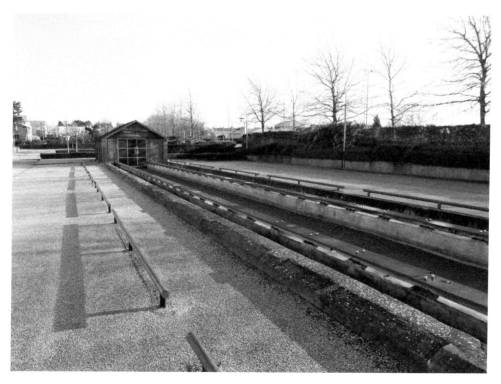

Building Q120.

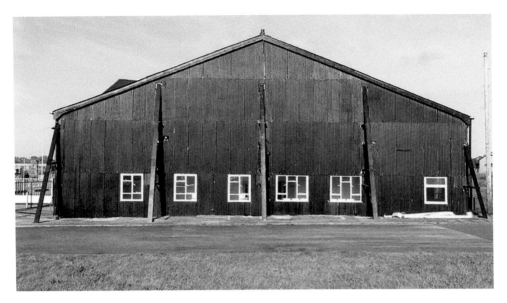

Building G29.

Pinehurst Park, formerly the site of Hillside House, is also located along Farnborough road towards the council offices. Purchased by French Sisters of Christian Education in 1889, it was used as a boarding school for upper-class young ladies. Between 1892 and 1895 it was extended to form Hillside Convent College, and in 1907 a further wing was added containing a refectory and concert hall. Following the college's move to Farnborough Hill in 1944, it became the College of Technology for RAE apprentices, and was opened in 1948 by the Chancellor of the Exchequer, Sir Stafford Cripps. It replaced the RAE's previous workshop-based 'Trade Lads' apprentice scheme.

From 1910–17 the 'Trade Lads' received no formal technical training other than that provided by the 'apprentice master' during 'on-the-job' training. From 1914 it was planned to provide every apprentice the opportunity to attend voluntary evening classes four nights a week, for 1–2 hours. In these classes practical mathematics was taught, with elementary mechanics, drawing and chemistry. However, with war looming these classes were deferred until 1917.

In 1957, a separate technological college known locally as 'Farnborough Tech' was established opposite the RAE College of Technology, and later in 1960, the two merged to form the Farnborough College of Technology. Today the older building has been converted to private flats.

Along Union Street, past the entrance to the cemetery, is a section of railway line that once served the RAE, delivering tons of materials, munitions and coal for the power station daily. It was laid by German prisoners of war in 1917 from the Cove and Firth Hill prisoner of war camps and used to run from Farnborough Main station, through Cove and into the RAE's ordnance depot. The line remained in use until it closed in 1968.

The parish of St Mark includes North Camp, stretching as far south as the north side of the Basingstoke Canal. Within this area a diverse collection of military buildings

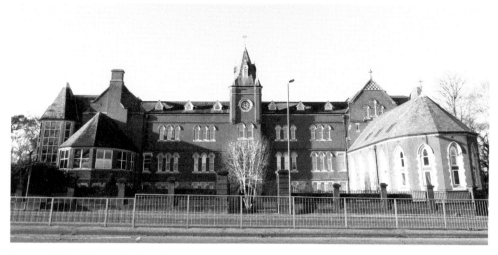

Former RAE College of Technology.

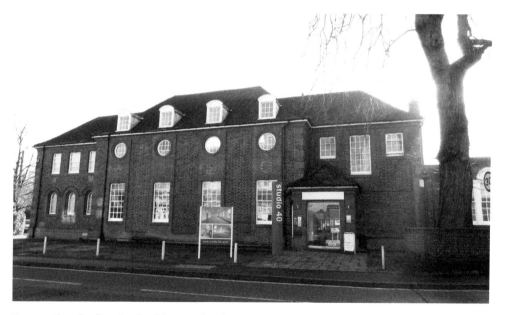

Former Church of England Soldiers and Sailors Institute.

exists that form part of Farnborough's military heritage. On Lynchford Road, opposite the junction with Alexandra Road, is the former Church of England Soldiers and Sailors Institute, now business units. The original Victorian orange-brick building opened in 1894 as a place where military men from the camp could go for 'home comforts' which could not be provided in their crowded barracks. Around the corner in Camp Road, a YMCA Soldiers Club was built around 1900. It provided recreational amenities, books, free papers and refreshments for service men; now it forms three shops.

Former YMCA Soldiers Club.

'The New Normandy Barracks' officers' mess in Evelyn Woods Road is located on the site of the former Connaught Hospital administration block, built in 1897–98, and is the only surviving building from Connaught Hospital. At the top of Queens Avenue by Redvers Buller Road are two buildings built in 1895 that were previously the Marlborough all-boys' and all-girls' schools for the children of military families. Today the purpose-built school, with its clock tower, is Marlborough preschool and infant school.

A little further down Queens Avenue, on the left, are a collection of buildings that now form the site of Aldershot Military Museum. These include the last two remaining brick-built bungalow-style barrack blocks in Rushmoor, built in 1881; a wooden guardhouse built in the 1930s; and a large barn that once belonged to Field Marshall Montgomery that housed his military caravans, now home to a collection of army vehicles and guns.

Further along Queens Avenue is 'Fox Lines', the home of the Royal Army Physical Training Corps (RAPTC). The main gymnasium, 'Fox Gym', was built in 1894 and named in honour of Lt Colonel Sir G. M. Fox, Inspector of Physical Training 1890–97. Beside 'Fox Gym' is the old military swimming bath. This was built in 1900 with funds of £12,000 donated by the Royal Military Tournament. It remained in use until the 1980s; before this time soldiers swam in the Basingstoke Canal or Cove Reservoir.

The site houses the RAPTC museum, which tells the story of the RAPTC and how physical training in the British Army has advanced from 1860 to the present day.

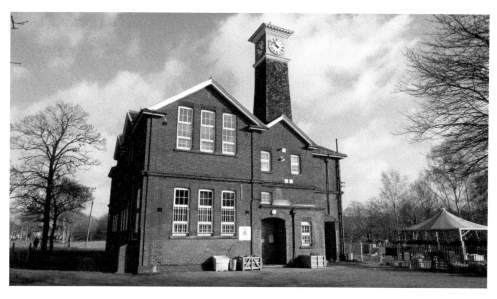

Former Marlborough all-boys' and all-girls' schools.

Opposite the RAPTC complex is a large expanse of open land known as Queens Parade, a grassed open area covering 89 acres that sits between the A325 Farnborough Road and Queens Avenue that stretches north from the Basingstoke Canal to North Camp. Queens Parade is so called because this was where Queen Victoria carried out her annual review and inspection of the garrison. The site used to host special events, such as the sizeable Army Show until its cancellation in 2010. Today it is used for recreational events, but when the Parachute Regiment were in residence the field was used by recruits from 'P Company' to make their static balloon jumps.

Opposite Queens Parade on the other side of the Farnborough road are two important military buildings, Vine Cottage and Blandford House. Formerly the residence for senior officers of the Royal Engineers, only the southern wing of Vine Cottage remains. Blandford House, a large detached military residence built around 1900, was, until 1950, the home of the General Officer Commanding, Aldershot District. It is now the base of employees of the Defence Estate.

Further along Farnborough road towards the Queens Hotel roundabout is Government House, built in 1873 as accommodation for the garrison commander. In 1903, the house became the garrison officers' mess and during the 1920s and 1930s military searchlight tattoos were held in the grounds. Today the Queen's Dining Room is used by the military to entertain important royal, political and military visitors.

Two of Farnborough's early housing estates also form part of the town's military heritage. When the First World War broke out in 1914, increased demands were placed on the Royal Aircraft Factory resulting in their workforce expanding significantly. To accommodate them, two bespoke housing estates were built by the Ministry for War. The first eight terraces of workers' cottages were built in 1915, 'Pinehurst Cottages', near to the factory. The second was Rafborough, which took its name from the factory and was built

Members of 23 Parachute Field Ambulance, above Queens Parade, 1988. (AAM)

Queens Parade Army Show 2008.

Queens Parade Army Show 2009.

Pinehurst Cottages.

between 1917 and 1920 at Cove, just south of Tower Hill and included a school, church and social club, all in wooden huts. Both estates were built with labour from German prisoners of war. Many of Farnborough's streets are named after famous military and aviation heroes who worked in the town and at Rafborough; some of the roads were named after famous people from the early history of aviation at Farnborough: Busk Crescent, Cody Road Goodden Crescent, Keith Lucas Road, and Fowler Road. Rafborough remained in the ownership of the Ministry of Defence until the 1980s.

These are not the only streets in Farnborough with a connection to military heritage. Following the Second World War there was a high demand for new accommodation, and a short supply of skilled labour and building materials. The government's answer was to build cheap prefabricated homes, made in standard sections off-site, which were shipped and assembled on-site. Two types were developed by the Ministry of Works' Emergency Factory Made programme: the Wimpey 'No-fines House' and the Reema 'Hollow Panel and 'Conclad' systems. Intended for the mass production of social housing, the 'No-fines' referred to the fact that concrete with no fine aggregates was used, making it cheaper and creating a distinctive and hollowed bubbled effect.

The 'Reema' construction method used precast reinforced concrete panels, lifted into place and bolted together. While design variations existed, the main difference was that Conclad had concrete external panels, strengthened by ribs on the inner face, which were not present in the Hollow Panel. Their distinctive appearance makes all three types easy to spot, with many still being used today.

Example of Reema hollow-panel system housing, Rafborough.

5. The War Years

During 1913 war clouds gathered over Europe, and while Britain's army and navy were gearing up for war, from an aeronautical perspective the nation was ill prepared for the challenges that military aviation would bring. On the battlefields, the static nature of trench warfare quickly saw aeroplanes performing aerial reconnaissance roles.

As the importance of aerial observation grew, the war on the ground moved to the skies, with both sides developing tactics to shoot down each other's aircraft. Machines were quickly fitted with forward- and rear-firing machine guns and adapted to carry an array of bombs and torpedoes. Large formations of aircraft replaced single patrols and sky duels; 'dogfights' became common, as each side fought to gain aerial supremacy.

The Royal Aircraft Factory (RAF) had been producing machines in sufficient numbers to test, evaluate and move British military aviation on to new heights. However, they could not match Germany's industrial scale of design and production. When Britain declared war on Germany in 1914, the RAF expanded its capacity, in both buildings and personnel. In 1910 the RAF employed 100 staff, by mid-1915 that number was 4,000 and by 1918 it reached just over 5,000.

In the early years of the First World War, besides manufacturing hydrogen and operationally servicing the Balloon and Kite squadrons, the RAF were responsible for experimental work, repairing and reconstructing aircraft of the Royal Flying Corps (RFC), as well as testing and repairing British and foreign engines/aeroplanes, including captured enemy aircraft. The RAF also continued to design aircraft for use by the RFC and provided technical training for their air mechanics.

In order to keep up with demand, the RAF kept production and repairs going by remaining operational day and night, seven days a week. To prevent key employees from being conscripted the RAF formed the Hampshire Aircraft Parks, Flying Corps Territorial Reserve (RFCTR), in October 1914. This placed 1,600 male employees under military law and the command of Lieutenant Colonel O'Gorman, the factory Superintendent, with various departmental heads being commissioned as officers.

In December 1914, the young male workforce at the factory were persecuted by members of a group the press dubbed the 'White Feather Headed Brigade'. Members of the newly formed 'Order of the White Feather' aimed to shame men not in uniform into enlisting by persuading women to present them with a white feather. Such was the level of persecution at the factory that Lord Kitchener, then Secretary of State for War, was petitioned by trade unionists. Kitchener's response was swift, appearing in every national and local paper.

'I should like all engaged at the Royal Aircraft Factory to know that it is fully recognised that they, in carrying out the work of providing aeronautical stores for the troops,

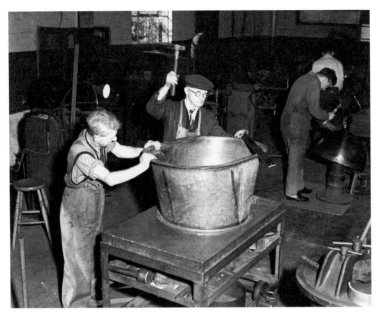

Sheet metal workers.
(FAST)

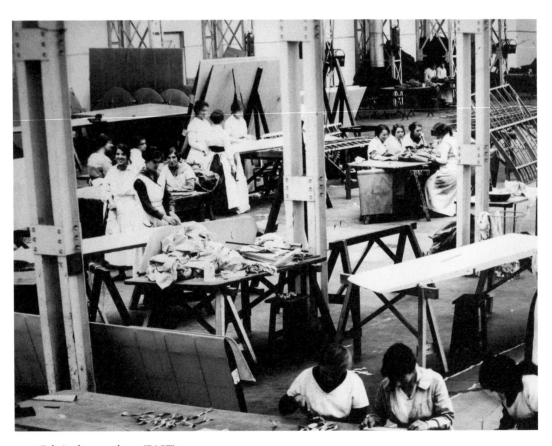

Fabric shop workers. (FAST)

are doing their duty for their King and Country equally with those who have joined the army for active duty in the field.'

Fed up with constant challenges to their being in civilian attire, male employees took to wearing a circular button with RAF in the centre; upon the back bore the wearer's war office number, and attached was an ivory tab inscribed with the wearer's name and an oath he was serving his country at the RAF.

The importance of the work being undertaken at the RAF was also commented on by King George V following his inspection in April 1915. The king wrote a personal message to the employees, which was printed, and a copy given to each one:

> I'm pleased to have the opportunity to express my appreciation of the grand work which is being done by the employees both men and women at the Royal Aircraft Factory at Farnborough. I am sure they are willing to put up cheerfully with the discomforts and difficulties both in connection with their long hours of work on war munitions such as aircraft, and their parts and accessories, is of vital importance to the British Army. Their work is of real value and they can all feel that by their exertions they are helping the troops in the field.

The factory designed, developed, produced, tested and modified many aircraft between 1915 and 1918, from reconnaissance planes, to single-seater fighters and bomber planes. Alongside this work, a host of armaments were being adapted or invented to fit machines that included Vickers and Lewis automatic machine guns, the Vickers rocket gun and searchlights for night flying. Work was also undertaken on the only flying boat design produced at the RAF, the CE1 (Coastal Experimental), designed for use against enemy submarines and fitted with guns and bombs.

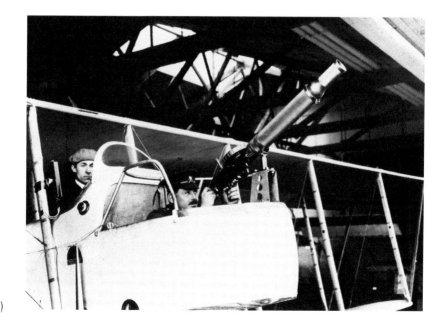

Maurice Farman Shorthorn with Lewis gun. (FAST)

From 1915, the RAF production mainstay was the BE2c aeroplane, which by 1917 had become the most controversial British aircraft of the First World War. Designed to provide stable reconnaissance, with its in-built stability it was a capable aircraft. However, with the arrival of the German Fokker EI, its lack of weaponry made it an easy target. With no suitable replacement available the BE2c remained in use on the Western Front longer than it should have done, gaining a worsening reputation as the war progressed.

The RAF became the subject of exaggerated criticism by MP Noel Pemberton Billing, British aviator, inventor, publisher, and founder of air manufacturing company Supermarine. Such was the relentless and vitriolic nature of his comments that many key staff left. Billing's concerns focussed on the failings of the BE2c and the advanced abilities of the Fokker, ignoring the real issue: a lack of suitable synchronisation gear for Allied aircraft. His constant attacks pressured the government into appointing the Bailhache Committee to investigate the way the RAF was governed and its role in supplying the RFC with aircraft. Their findings suggested the RAF should not continue as a manufacturing establishment, a key concern of Billing and other private manufacturers, who felt the government-backed RAF were monopolising the industry. In response, in 1917 the RAF developed and produced the SE5 aeroplane, considered by pilots as one of the best British fighters of the war. However, following the manufacture of the SE5 no further planes were produced by the RAF.

In 1916 work started on radio-controlled pilotless aircraft to be used as a defence against the German Zeppelin airship and for use as a flying bomb. Throughout the war, the RAF produced over 500 aircraft of thirty different designs, the majority being prototypes that were mass produced by private companies. With the creation of the Royal Air Force

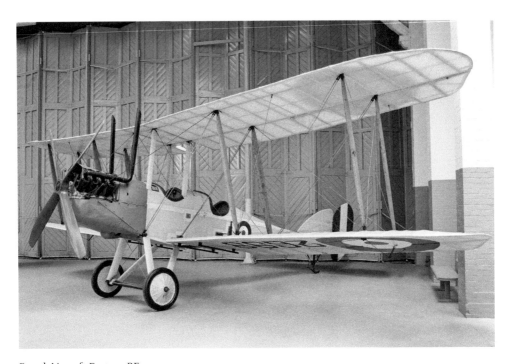

Royal Aircraft Factory BE2c.

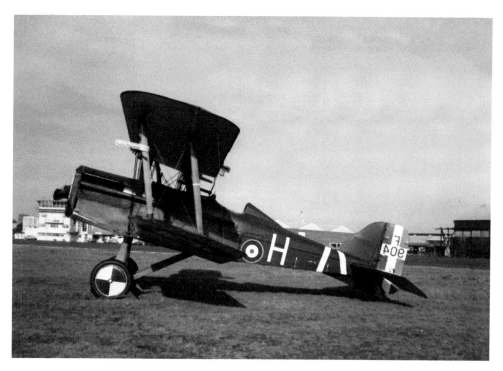

Royal Aircraft Factory SE5a. (FAST)

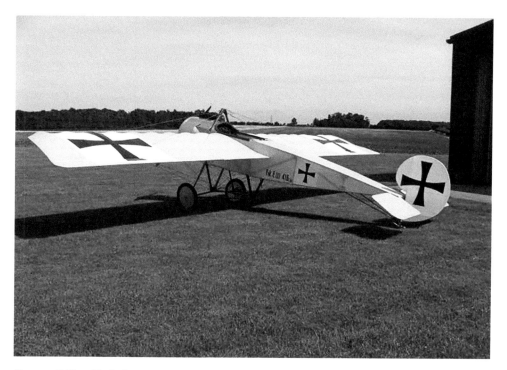

German Fokker Eindecker.

in April 1918, the RAF became the Royal Aeronautical Establishment (RAE). Its work became more specialised and moved beyond the testing and production of aircraft to the manufacture and testing of equipment in flight. As a result, the RAE lost many of its best designers, and when the war ended the establishment was reduced to 1,000.

1939–1945

When the Second World War broke out, the RAE's workforce at Farnborough once more swelled, with notable inventors, scientists, engineers and ancillary workers joining from all over the UK. Numbers rose from just over 1,000 pre-war to 6,000 by 1945. In 1939 urgent work began to enlarge the airfield, and building new runways, hangars, workshops, and taxiways. The site now covered over 800 acres – 700 acres more than it had thirty years earlier.

The war physically impacted Farnborough during the summer of 1940 when the quiet, rural and slow-pace nature of the town changed. It rapidly became a cosmopolitan hub and a hive of activity, as the surrounding camps at Southwood and Minley filled with troops from the internationally diverse French Foreign Legion, and regulars from the armies of France, Belgium and Poland. These were the remnants of a beaten force rescued from the beaches of Dunkirk between 26 May and 4 June 1940.

At Cove, the Foreign Legion's presence was as memorable as its reputation, with one Legionnaire, Jacques Bauer, a Frenchman, being charged with the murder of another Legionnaire, Swiss-born Traugod Breitenstien. Bauer was accused of stabbing his comrade to death following an altercation in the barracks. A civilian police investigation at Aldershot was unable to locate any witnesses or secure evidence to prove Bauer's guilt and they released him into the custody of the French military authorities. Bauer was never heard of again.

No sooner had these troops vacated the camps, than the Canadians moved in. Thousands arrived; reinforcements needed to defend the UK. They were stationed across the camps at Southwood. These included Morval Barracks East and West, where the Princess Patricia's Canadian Light Infantry and the Edmonton Regiment were stationed. Delville Barracks East and West hosted the Canadian Seaforth Highlanders, the Carleton and York Regiment and the Queen's Own Cameron Highlanders of Canada. At Guillemont Barracks, along the Minley Road, were the West Nova Scotia Regiment, the Les Fusiliers Mont-Royal, and the Royal 22nd Regiment of Canada, Calgary Highlanders. Many Canadian units would follow as Britain and her allies prepared to open up a second front in Europe.

With the return of the British Expeditionary Force from Dunkirk, Britain was once more gripped by the fear of invasion. Many military leaders believed that an amphibious assault would be preceded by an aerial invasion of paratroopers and gliders. In response, military installations erected countermeasures, and at Farnborough parts of the airfield on Laffan's Plain were seeded with mines and large poles connected with wire. Large sections of woodland were cleared, and observation posts and pillboxes were erected to provide defensive fire.

Before Germany could launch such an invasion, they needed to control Britain's airspace, and this battle took place between 10 July and 31 October 1940. The Battle

of Britain, as it became known, was a decisive air campaign fought over southern England. For Germany, the 13 August 1940 marked the start of their campaign to gain air supremacy and, if successful, it would have paved the way for 'Operation Sealion', the invasion and conquest of Britain. Code-named 'Adlertag' (Eagle Day), wave after wave of enemy planes attacked ports, docks, airfields and other strategic targets across Essex, Kent, Sussex and Hampshire. The attack took place over a ten-hour period during which the Luftwaffe flew 1,485 sorties against Britain with Fighter Command flying 727 in response.

While the aerodromes at Odiham and Farnborough were targeted that day, neither were attacked. Farnborough, its airfield and the RAE were attacked on 16 August at 4 p.m. by a flight of eight Junkers 88 A-1s of KG54 squadron, who dropped twenty 110 lb (50 kg) and twenty 500 lb (250 kg) bombs, many of which were fitted with delayed action fuses. Half the bombs fell on the RAE; the rest fell in the residential areas of Albert Road, Church Road East, Reading Road and Canterbury Road. In Albert Road, several houses were destroyed including resident Mrs Brown's. Fortunately, she had taken refuge in her garden's Anderson shelter with her children, and escaped injury or worse. Several residents received minor cuts and bruises from flying glass and masonry, but none were injured or killed.

Within the RAE area, two bombs had fallen simultaneously on Sydney Smith Road, causing the roof of a brick-built shelter to collapse killing RAE employees John Parkhurst and Allen Dixon. A third employee, John Shefford, died two days later in hospital. All three men were members of the 25th Hampshire Battalion, Home Guard, known at the time as

RAE bomb damage, 1940. (FAST)

RAE Local Defence Volunteers (LDV), made up only of RAE employees. All three lived at Rafborough and were on duty at the time of the attack, becoming the first volunteer casualties of any LDV unit.

Parkhurst and Dixon were buried with full military honours at St John's Church, Cove. The coffins' route to the cemetery passed along Victoria Road, lined with hundreds of mourners. Every shop had closed their blinds as a mark of respect, and each coffin was

Left: Graves of John Parkhurst and Allen Dixon.

Below: RAE, 25th Hampshire Battalion, Home Guard.

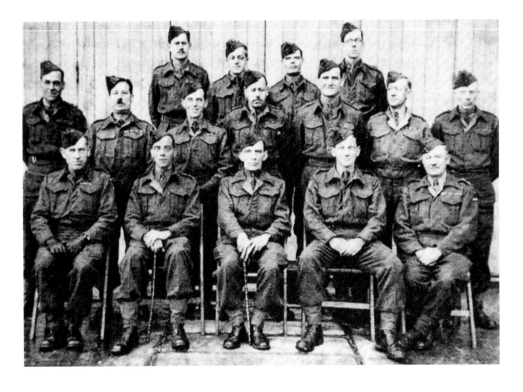

draped with a Union Jack and carried upon a gun carriage. Behind the carriages hundreds of volunteers from neighbouring LDV units marched in file, along with soldiers from local regular units. Among the many hundreds of people attending the funerals were Lord Rotherwick, and many senior officers from units stationed in Farnborough and Aldershot. The service was conducted at the graveside, three volleys were fired over each grave and the Last Post and Rouse, sounded by trumpeters of the 12th Lancers, signalled the end of the service. Shefford was buried with full military honours at St Mary's Church, Eversley.

In response to the bombings, the RAE's Experimental Flying Department formed a 'Duty Defence Flight' to protect the airspace above Farnborough utilising their own fleet of Spitfire, Hurricane and Gladiator aeroplanes. Almost a year later, on 13 of August the RAE LDV (now the Home Guard) lost another of its ranks when Allen Dixon's son Jimmy was killed in a motorcycle accident in Aldershot. Jimmy, who had helped carry his father's coffin, was buried with full military honours in his father's grave, in the presence of relatives and members of the Home Guard who had attended Allen's funeral.

Despite the RAE's industrial and strategic importance it was not attacked again. However, the residents of Farnborough were not so lucky; a daylight attack on 28 October 1940 resulted in several houses being bombed. Although no lives were lost, several people had lucky escapes. Among the worst damaged was No. 2 Yetminster Road, home of the Yeoman family. At the time of hearing the explosion twenty-year-old Doris had been upstairs in her bedroom when everything went dark. The next thing she remembered was waking up at the foot of the staircase covered in dust and plaster, staring at the bright blue sky where the roof had been moments earlier. Ironically, the leader of the Civil Defence Heavy Rescue Team was Doris's father Charles, whose first duty in this role was

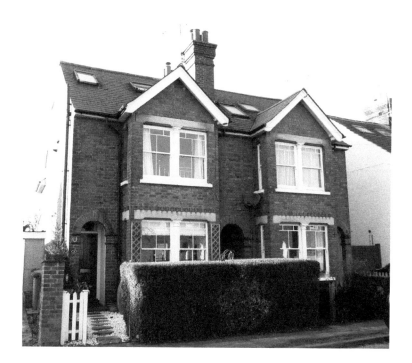

No. 2 Yetminster Road.

to make good his own home. It later emerged that the bombs were not dropped by the Luftwaffe, but by a flight of Fiat BR 20s from the Italian Regia Aeronautica. Following their arrival in Belgium in September 1940, they conducted bombing missions over southern England, the intended target on this occasion most likely being the RAE.

The residents of Farnborough remained in fear of being bombed throughout the war, and while no further bombing raids were carried out over Farnborough, odd bombs were dropped by enemy aircraft returning from missions further inland. These caused minor damage and no serious casualties, as did the German fighters who on two separate occasions flew low over Farnborough firing their machine guns at unsuspecting residents, causing them to scramble for cover.

Fears of bombing raids and fighter attacks continued throughout the war years, fuelled by frequent sightings of enemy planes silhouetted in the skies above Farnborough. In the main these were false alarms, captured German planes with British markings being tested and evaluated by pilots from the RAE. The first captured German aircraft arrived at Farnborough on 14 May 1940, a Messerschmitt Bf 109E-3, which made seventy-eight flights during the fourteen months it was at Farnborough. The second arrived on 14 August that year and was a Heinkel HE 111H-1. Three months later, the Italian Regia Aeronautica returned to Farnborough. This time they came by road, when a captured Fiat CR.42, shot down over Suffolk during the Battle of Britain, arrived on 11 November.

The year 1940 saw the creation of the RAE Radio Department. Previously known as the Experimental Wireless Department, they conducted successful trials of VHF air-to-ground transmissions, Identification Friend or Foe (IFF), jamming equipment, radio altimeters, VHF communications, aircraft aerials, auto pilots, Radio Direction Finding (RDF) and Ground Control Intercept (GCI).

In 1941, the RAE Chemical and Fabric Department began experiments with camouflage patterns for aircraft, airfields, buildings, tents, vehicles and ships according to the theatres in which they operated. Farnborough also received large quantities of captured German

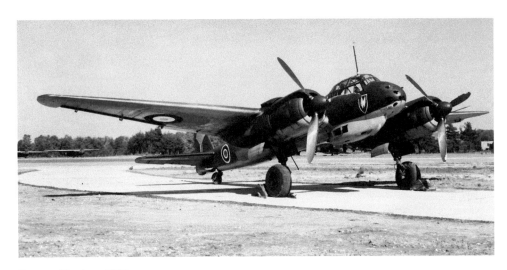

Captured Junkers JU88.

Captured Dornier 335A.

equipment for analysis, including radar components and a German technician seized during 'Operation Biting', a raid on Bruneval radar installation, on the French coast. In October 1942 the RAE received the first American B-17 Flying Fortress, used to conduct sky brightness measurements at high altitude and gun-firing tests.

As the war drew to an end, residents' fears turned from bombing raids to strikes by V-1 flying bombs and V-2 rockets, and while Aldershot was hit by a V-1 rocket, Farnborough was not. Although neither town was hit by a V-2, the RAE did take possession of one in July 1944. This had crashed in Sweden, and examinations enabled scientists to discover its effectiveness before its first use against Britain in September 1944.

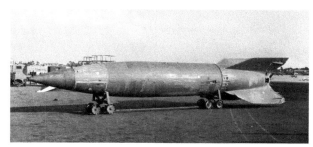

Above: Reconstructed V-2 rocket. (FAST)

Right: Early camouflaged fabric experiment. (FAST)

6. Monuments and Memorials

Farnborough's collection of monuments, memorials and rolls of honour are dedicated to the men, women and animals who have served their country. They are unique reminders of the town's diverse military heritage and form an important part of its historical character.

The oldest military memorial in Farnborough is located on the Queen's Roundabout – a drinking fountain and horse trough built in 1903. Connected to the second Boer War (1899–1902), it is something of a mystery and takes the form of pillars made of Portland stone, set into a low semicircular wall with steps on either side. It bears a simple dove with an olive branch in its beak, and the inscription 'In memory of one who died for his country MCM' (Roman numerals 1901). While the architect, Miss Clotilde Brewster (Westminster), and builder, Mr Hammond (Farnborough), are known, nothing further is known about the donors, or to whose memory it was erected.

In September 1903 the editor of the *Aldershot News* wrote 'Someone in particular fell. Some friends in particular were bereaved, but it stands there at the crossroads, the nameless fountain in quiet dignity of an impersonal symbol to the valiant. From the true to those who strive from those who love. No more suitable or significant memorial could have been thought out by the anonymous donors.'

Another Boer War memorial is located at St John's churchyard, Cove – an obelisk dedicated to three local parishioners who died on active service during the South

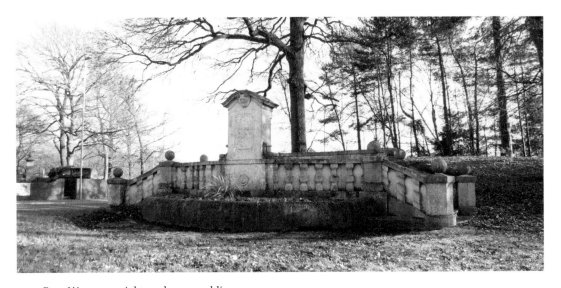

Boer War memorial to unknown soldier.

African War 1899–1902. They are Corporal William C. Hazell, Hampshire Regiment (pneumonia); Private Charles Rance, Army Service Corps (enteric); and Trooper Thomas Henry Hill, Imperial Yeomanry (scarlet fever.)

Following the First World War, towns and villages commemorated the loss of residents by erecting stone crosses or monoliths. However, the residents of Farnborough felt that wasn't good enough and commemorated their men by creating a memorial hospital.

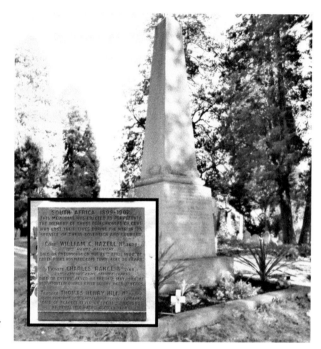

Right: Boer War memorial, St John's Church.

Inset: Front Boer War memorial, St John's Church.

Below: Farnborough and Cove War Memorial Hospital.

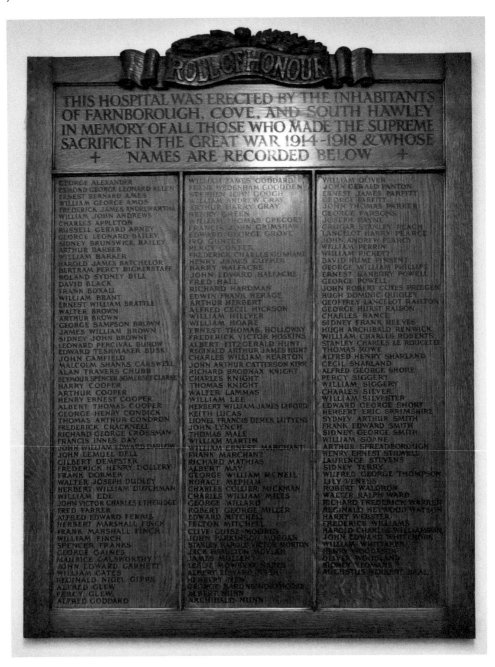

Roll of Honour, Farnborough and Cove War Memorial Hospital.

A large property in Albert Road was purchased and converted into a twelve-bed hospital for the community. At the back of the cottage hospital was Farley House, which was acquired and turned into a maternity hospital. Together they became known as the Farnborough and Cove War Memorial Hospital.

Opened in 1921 by Field Marshal Earl Haig KT GCB OM GCVO KCIE, the hospital ceased serving the community in 1974. Following public pressure to preserve the building, the Farnborough and Cove War Memorial Hospital trust was formed in 1976 and in 1984 the trust purchased the building, renaming it Devereux House. Now a residential care home and day centre, inside the entrance 182 names of local men who died during the First World War are listed.

Keeping this tradition, at the conclusion of the Second World War, the people of Farnborough held a referendum, at which it was agreed that a memorial to those who lost their lives during the conflict should take the form of a care home. When Knellwood Hotel, a former First World War hospital, became available in 1947, the Farnborough War Memorial Housing Society Ltd was formed and purchased the property. Later that year, the building was dedicated as Knellwood Memorial Home, and a wooden roll of honour was erected inside the house commemorating 155 men of the district who fell through enemy action.

The men of Farnborough and Cove who served, fought and died in service during the First and Second World War are also remembered throughout the town on other rolls of honour. Remembering the citizens who died during the First World War, the Rushmoor Remembers Roll of Honour is accessible online, with hard copies available at Rushmoor Borough Council offices, Aldershot Military Museum and at the Aldershot and Farnborough libraries.

Inside St Peter's Church is a white marble roll of honour to 'The Men of the Parish' who died during the First World War. Uniquely, it lists the names in the year they died and

Knellwood Memorial Home.

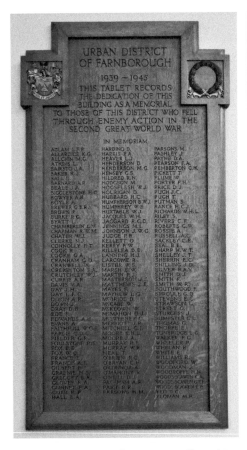

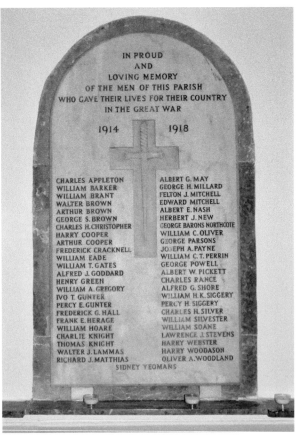

Above left: Roll of Honour, Knellwood Memorial Home.

Above right: 1914–1915 Roll of Honour, St John's.

also states that eighty men served with forty returning and forty dying. The youngest not to return was Alfred Edward Ferris, aged sixteen. He joined the Royal Navy as a Boy 2nd Class aged fifteen and died from lung disease whilst in training on HMS *Impregnable*. Above this memorial is another roll of honour in the form of a stone tablet listing the names of thirteen men who died during the Second World War.

Inside St John's Church among the private and family memorials are two beautiful stone arched Rolls of Honours commemorating the sixty-nine men of Cove (forty-nine WW1 and twenty WW2) who died during both world wars. The youngest is Private Albert Pickett who enlisted aged sixteen days after his two older brothers joined up and was just seventeen years and two months when he died of pneumonia in present-day Pakistan.

In Reading Road opposite St Mark's Church stands a shelter containing a handwritten roll of honour listing the names of 231 men who died during the Great War. Inside the church is a Memorial Chapel, the only one of its kind in Britain; it is dedicated to

the men of the Royal Flying Corps who served locally. Originally the 'Lady Chapel', its wooden-panelled walls commemorate 190 local men and women who died in the service of their country. A small wall plaque commemorates the boy entrants of the Farnborough Royal Air Force School of Photography, who served and died during the Second World War.

A distinctive life-size brass and marble Gothic memorial in the floor of the chapel is dedicated to local brothers Lieutenant Colonel Geoffrey Charles Shakerley and Captain Eric Piers Shakerley who served in the King's Royal Rifle Corps. Both died within three months in 1915, and a third brother, Second Lieutenant Arthur Cecil Shakerley, serving with Royal Field Artillery, died in 1917.

Salesian College, like most of Britain's educational establishments, lost former pupils during both world wars and fifty-eight former pupils, 'Salesian Old Boys', are remembered on four wooden rolls of honour displayed around the school. It's not known how many underage 'Old Boys' joined the forces during the war years; however, one known case during the First World War is that of Edward Victor Wells Haddy, a boarder at the college

Roll of Honour, Reading Road.

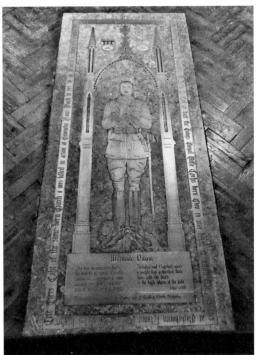

Above left: RFC Memorial Chapel, St Mark's.

Above right: Brass memorial, St Mark's Church.

who joined the 7th Battalion of the London Regiment in August 1914 aged seventeen. His regiment was mobilised to Bethune, France, between 8 and 22 of March 1915 and was the second complete territorial division to arrive in France. Their first action was on 27 March, during which Haddy was killed. He is buried at the Brown's Road Military Cemetery, Festubert, France.

Also listed are brothers Joseph and Thomas Elley who, while at the college, lived in York Road, North Camp. Joseph served with the Royal Dublin Fusiliers, arriving in France in August 1914. He took part in the battles of Le Cateau, Marne, Aisne, and Messines, Belgium. Between 22 March and 25 April 1915 Joseph fought in the second battle of Ypres, Belgium, being wounded by shrapnel in July. A year later, aged twenty-six, he was killed in France during the opening day of the Battle of the Somme.

His brother Thomas joined the Royal Scots Fusiliers and also arrived in France in August 1914, taking part in battles across France and Belgium at Mons, Marne, Aisne, and Messines, La Bassee, Armentieres, Nonne Bosschen, Ypres, Wytschaete. In 1915 and 1916 Thomas was involved in key attacks on several German positions culminating with fighting at the Somme in three major engagements. In early April 1917, Thomas's service record shows he received a gunshot wound to the stomach and right forearm and was hospitalised. He rejoined his unit when deemed recovered but was killed in action on 28 December that year.

Salesian College Hall Rolls of Remembrance.

1914-1918

B.AMBROSE	P.CORNU
C.ANDREWS	J.COROW
J.ASPELAGE	C.CREIGHTON
A.BARBER	J.CREPELLE
H.BARRETT	W.CUNNINGHAM
F.BARRINGTON	L.DENTON
J.BEER	A.DONKIN
H.BERTOLA	J.ELLEY
W.BIRD	T.ELLEY
J.BOUGUEL	N.FELTIN
P.BROUGHTON	F.FOND
J.BROWNING	D.GALLACMANTI
L.CHRETIEN	F.GARNIER
J.CLARKE	J.GILBERT
W.CONNOLLY	A.GOUDIS

1914-1918

F.GRENHAM	B.MARCELLE
E.HADDY	J.MARTIN
J.HEALEY	S.MARX
N.HEALEY	J.McGRAIL
W.HOWARD	G.PIERRAT
F.INGLIS	P.PIGNETTI
E.JERVOIS	H.QUIGLEY
C.JUDGE	P.REYNARD
J.KELLY	J.SEPTAN
A.LAVENDER	J.STEVENS
W.LE GALLEY	D.SULLIVAN
J.LOGAN	T.WALSH
E.MAHONEY	A.WILDE
G.MARCE	M.WILLEMS
P.F.BONTEMPS	W.B.POWER
J.KERANS	

Above left: 1914–1915 Roll of Honour, Salesian College.

Above right: 1914–1915 Roll of Honour, Salesian College.

1939 - 1945

Chaplain Fr ANDREW BOYLE SDB, CF
Mr BERNARD BROWNE-MOI, MID
Flt Lt RICHARD G. BURKE, RAF, AFC
Sgt FRANCIS T. CONNELLY, RA
Petty Off WILFRED CRANWELL, RA
Sgt JOSEPH DOWN, RAMC
Sgt Inst ANTHONY EVANS, RAF, USAFM, MID
Sgt A. FRANCE, RAF
Flg Off PERCIVAL S. GRIFFITHS, RAF
Plt Off DONALD R. HARDING, RAF
Plt Off MATTHEW R. HODGSON, RAAF
Chaplain Fr DAVID F. HOURIGAN SDB, CF
Able Seaman PETER R. JUDGE, RN
Petty Off OSWALD R. KELLET, RN, MID
Plt Off PHADRIC W. KERRY, RAF
Plt Off JOHN P. MERRITT, RAF
Flg Off CYRIL I. MITCHELL, RAF, DFC
Petty Off WALTER L. McCABE, MN
Sgt Off PATRICK J. McDONNELL, RAF

1939 - 1945

Flt Lt CONAL B. McSWEENEY, RAF, DFC
Sgt Pilot JOSEPH A. MOORE, RAF
Sgt Gunner THOMAS NEALE, RAF
Flt Engineer PETER Q. O'BRIEN, RAF
Sgt Gunner ARMEL G. O'CONNOR, RAF
Capt Dr JAMES P. O'FLYNN, RAMC
Flt Lt DESMOND H. O'NEILL, RAF, DFC
Petty Off MAURICE PARSONS, MN
Schoolboy JACK PASHLEY
Plt Off JOHN C. PUGH, RAF
Wg Cdr THOMAS P. PUGH, RAF, DFC, CAC
Petty Off SILVESTER J. PUTMAN, RN
Plt Off WILLIAM P. REIDY, RAF
Flt Lt ANTHONY A. ROSSIE, RAF
Staff Sgt WILLIAM A. SPAUL, COM.F
Plt Off GEORGE D. SPROULE, RAF
Lt LAWRENCE P. STRAWSON, RA
Fr GEORGE STREET, SDB
Flt Sgt GERALD B. THOMAS, RAF

1939 - 1945

Cpl PETER J. THOMAS, RTR
Sgt WILLIAM TURNER, RAF
Sgt JOHN W. WELLING, RAF
Sgt Plt WILLIAM L. WOODFORD, RAF
Plt Off PAUL I. WHEELER, RAF
Plt Off CHARLES A. WOODS-SCAWEN, RAF, DFC
Plt Off PHILIP P. WOODS-SCAWEN, RAF, DFC
Sgt Plt GERALD E. WOODS-SCAWEN, RAF
AC 1 WILLIAM DIXON, RAFVR
———— KOREA 1950-53 ————
Private PETER C. RESSIA
Private PETER J. DAVIS
— SOMALIA - 02 JANUARY 1993 —
Aid Worker SEAN DEVEREUX, UNICEF

Above left, above right and left: 1939–1945 Roll of Honour, Salesian College.

During both wars, many Salesian Old Boys received gallantry awards for daring and bravery in the face of enemy action; others were decorated for their determination and dedication to duty. Between the fifty-eight men remembered there were nine Distinguished Flying Crosses, two Distinguished Flying Medals, two Air Force Crosses, four Distinguished Service Orders, eight Military Crosses, four Military Medals and four Croix de Guerre medals. A total of fifteen Distinguished Flying Crosses were awarded to pupils from the college during the war, more than any other school in the UK.

Two recipients were brothers Patrick and Anthony Woods-Scawen who independently joined the Royal Air Force Reserve (RAFVR) during the 1930s. Both had become officers, both flew hurricanes and both experienced combat during the Battle for France and the Battle of Britain. During engagements with the enemy, both brothers had been shot down and bailed out several times. On other occasions they managed to crash-land their planes and each sustained shrapnel and bullet injuries. Both brothers became air aces and were each awarded the Distinguished Flying Cross.

The college and Woods-Scawen family were dealt a devastating blow when Patrick was killed on 1 September 1940 during combat over Kent. With his plane on fire, he bailed out too late for his parachute to open and fell to his death. In a cruel twist of fate, the following day, unaware that his brother was dead, Tony was also killed in combat

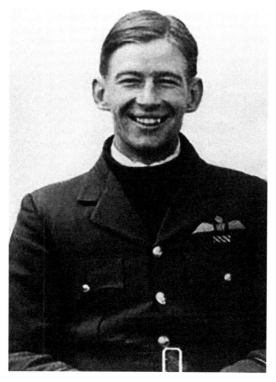 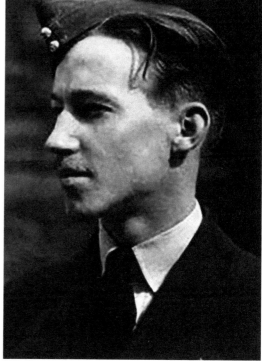

Above left: Patrick Woods-Scawen.

Above right: Anthony Woods-Scawen.

over Kent when his plane caught fire and he too bailed out late and was killed when his parachute failed to open. Twelve months later their cousin and former pupil Gerard Woods-Scawen died when he was shot down over the Channel on 3 October.

Also remembered are former pupils and residents of Farnborough Thomas and John Pugh and like the Woods-Scawen brothers, they joined the RAFVR. John, a pilot officer, died near the village of Dilwyn on 21 May 1940, when the Spitfire he was flying suffered an engine malfunction forcing him to make an emergency landing. Despite thick black smoke from the engine seriously reducing his visibility, he attempted to land in a field. At the last moment, through the smoke, Pugh saw a farmworker in his path and having swerved to avoid him, struck two oak trees, killing him instantly. His brother Thomas, Acting Wing Commander and DFC holder, died on 2 August 1943 at Dunkirk harbour when he was shot down by flak in his Typhoon during a coastal raid.

Among the many tragic accounts that accompany those remembered on the college's rolls of remembrance, William Dixon's story is a reminder that many abhorrent war crimes were also committed. Dixon enlisted in the RAFVR as an air mechanic in 1941 and was posted to Singapore. In 1942, the Japanese overrun Singapore and he became a prisoner of the Japanese Imperial Army. In late 1943, William, along with 548 other prisoners of war (POWs), was being transported to a main camp by the SS *Suez Maru*, a Japanese passenger-cargo ship. It was torpedoed and sunk by a US submarine unaware of the presence of allied prisoners. Half the prisoners drowned in the ship's hold, but the rest escaped and jumped into the water. Japanese authorities reported all allied prisoners had 'drowned at sea'. During a war crimes trial in 1949 a Japanese naval lieutenant testified that those allied prisoners who had survived the sinking were murdered – shot dead in the water.

In 1941 the age for joining the army was twenty. Undeterred, pupils Tom O'Brien, a week past his sixteenth birthday, and sixteen-year-old schoolfriend Peter Griffiths added two years to their age and joined the Hampshire Young Soldiers Battalion, created to train soldiers in readiness for enlistment. In December 1942 both boys were selected to join the newly formed 21st Independent Company (The Pathfinders) of the Parachute Regiment. The role of the pathfinder was to arrive at the drop zone half an hour before the main body of airborne troops, to set up beacons to pinpoint the drop zone for the advancing aircraft, and to clear any obstacles from the zone, and to defend the immediate area from enemy interference. In 1943, still only seventeen, O'Brien and Griffiths saw action parachuting into Catania, Sicily, to prepare the way for troops attacking the strategical important Primosole Bridge.

O'Brien and Griffiths next saw action at Arnhem, Holland, in September 1944, code-named Operation Market Garden. Both boys were dropped at 12.30 a.m., ahead of the main force. Griffiths was wounded during the drop and lost a leg. O'Brien landed safely and later took part in the fierce defence of Oosterbeek, where the 21st Independent Company's performance was exceptional, with many awards for bravery being issued. For his part O'Brien was mentioned in dispatches and during the defence, in which almost a third of the company were killed or taken prisoner, O'Brien was wounded. He was eventually captured and taken to a prisoner-of-war camp near the Polish border and along with Griffiths and fellow Salesian Old Boy Peter Thomas were declared missing in action.

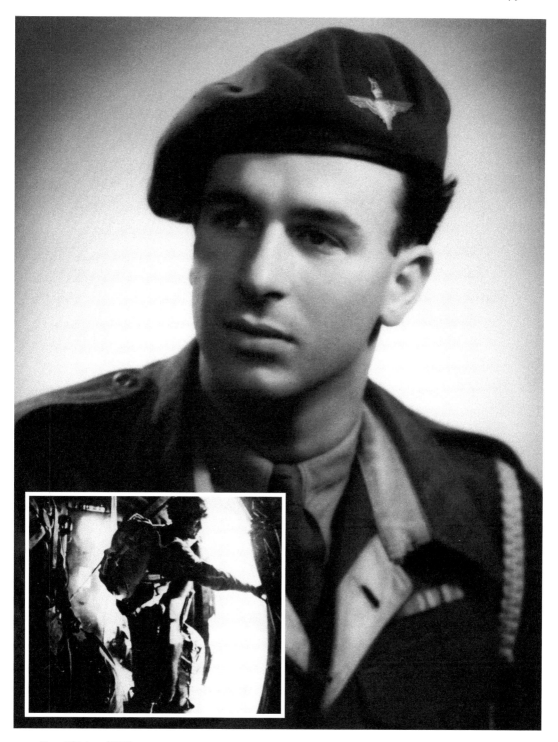

Tom O'Brien. (HW)

Inset: Tom O'Brien on a training jump. (HW)

Word of O'Brien's capture only came just before Christmas, and four months later with the Soviet Army advancing, German authorities began a mass evacuation of their POW camps. O'Brien was among the 80,000 POWs forced, in extreme winter conditions, to take part in what has become known as the 'The March'. In February 1945 his camp, ill prepared for the evacuation, and wearing unsuitable clothing, were marched westward a distance of 350 miles, during which many prisoners died. However, O'Brien, aged just twenty, survived. Griffiths, who had been hospitalised, also survived, but Thomas had been killed in action at Arnhem.

Notwithstanding Farnborough being the birthplace of powered flight, there are few commemorations to the early pioneers of the air who lived, worked and died here. Samuel Cody, the first person to pilot a powered and sustained flight in Britain in 1908, has three – a bronze statue outside the Farnborough Air Sciences Museum, a granite block near the Aviator Hotel marking the take-off point of that flight and a facsimile of a tree, the 'Cody Tree'. He tied his machines to this tree when testing the static thrust generated by propellers. Despite efforts in 1957 to preserve it, the tree continued to deteriorate, and as a result a replica was cast in aerospace-grade aluminium alloy which today stands on the Cody Technology Park.

Located within the grounds St Michael's Abbey is a monument to four monks of the abbey who died during the First World War. When Germany declared war on France on 1 August 1914, the French monks of St Michael's Abbey were living in exile following changes in 1905 to French law that suppressed religious orders, confiscating their property and which separated religion from politics, rendering it powerless.

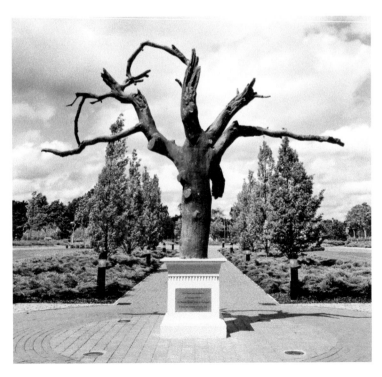

Cody's Tree.

In the weeks that followed Germany's declaration of war in 1914, the monks who'd been so unwelcome in France received call-up papers requiring them to fight for their country. They were not alone in this call to arms, with monks of other nationalities receiving notifications requiring them to serve their countries. Some monks like Dom Villecourt and Brother Francis Belbech were initially considered too old to fight and exempted, but were later required to serve. Others such as Dom Dumaine and Pere du Boisrouvray were declared physically unfit for military service and although not interred as an enemy of the state, eighty-year-old German lay-brother Joseph Becker was required to register with the local authority who restricted his movements to a 5-mile radius of Farnborough. Italian-born Dom Bertini had never lived in Italy, but in June 1916 he journeyed back to join the Italian army only to be rejected on the grounds he had become a naturalised British subject. Bertini returned to Farnborough and in May 1917 joined the British Royal Army Chaplains Department. He returned to Italy and served on the Italian front. He died from Spanish flu in September 1918 and was buried at Farnborough Abbey Roman Catholic churchyard with full military honours.

The monks who left the abbey saw service throughout Europe with the Red Cross, French, Belgium and British armies. As British conscription regulations changed, representations were made to the government by ecclesiastical authorities on behalf of the non-clerics at the abbey, lay-brothers Alban Pickett, Paul Lacey, and Anthony Cooper,

Above: Dom Godu. (SMA)

Right: Dom Olivieri. (SMA)

who'd become eligible for service. Although the decision made by the authorities did not exempt them, they were never conscripted.

In all, four monks died on active service. During his short service, Dom Frere Savignac was mentioned in the à l'ordre du jour – a roll of honour giving recognition from a senior commander for acts of brave or meritorious service, having previously been awarded the Croix de Guerre (a French military decoration awarded to individuals who distinguished themselves by acts of heroism in combat with enemy forces). He died on 18 February 1915 having joined the French Army as a lieutenant of the 59th Infantry Division on 3 August 1914. Dom Guthrie became a French army chaplain who died on 25 November 1916 from wounds received in battle and Dom Debroise, also a French army chaplain, died in 1921 as a result of injuries he sustained. All four monks are commemorated within the abbey grounds on an obelisk. Dom Bertini's grave near to the obelisk is marked by a Commonwealth War Graves Commission headstone. Other monks who joined the French Army and went to war were Dom Pere Gaston Godu, who was mentioned three times in dispatches for his acts of courage and also awarded the Croix de Guerre and Dom Louis Gougaud and Dom Pere Jean Perret, who were captured, and held as prisoners of war. All three returned to the abbey in 1919.

Louis Napoleon, the Prince Imperial of France and son of Empress Eugenie and Napoleon III, is also buried at St Michael's Abbey. While exiled in Britain, he petitioned Queen Victoria via Empress Eugenie to allow him to join the British forces in Zululand. He was granted permission to join the army as a lieutenant but only in an observational,

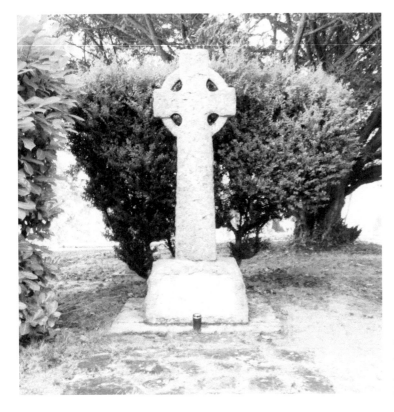

War memorial to Farnborough Abbey's French Monks.

Dom Bertini's Commonwealth War Graves Commission headstone.

non-arm-bearing role. Louis was attached to the staff of Frederic Thesiger, 2nd Baron Chelmsford, and commander of British forces in South Africa. Louis accompanied Chelmsford on his march into Zululand and on 1 June 1879, was given permission to join a small British reconnaissance patrol scouting along the Jojosi River valley. Around midday, at his insistence, they stopped to rest at an abandoned farmhouse, where, having failed to deploy sentries, they were ambushed by a small party of Zulus. During theconfusion that followed the prince in an attempt to seize the straps of his saddle lost his sabre,and in attempting to mount his horse fell, injuring hisright arm.

On foot and outnumbered, he emptied his revolver at the advancing warriors, and only when he ran out of ammunition, was he overpowered and killed along with two troopers and a guide. The next morning his body was recovered, pierced seventeen times by spears, including one through his eye. His death sent shockwaves throughout Europe, as he was the last serious dynastic hope for the restoration of the House of Bonaparte to the throne of France. His body was returned to England and buried at the abbey with full military honours. Within Aldershot Military Museum is a gallery to Empress Eugenie and the Prince Imperial that includes his death mask.

In 1880, a small cemetery was created in the grounds of Government House that today contains the graves of five military horse. The cemetery now lies next to a green on the army's golf course. Among the graves are Princess, the charger of General Sir Archibald Alison, Commander for Aldershot division 1883 to 1888. Princess served in Her Majesty's army for twenty-one years, dying on 6 September 1888 aged twenty-six. Also at rest are an unnamed 'Grey' horse ridden by Lieutenant General Sir John French during the Anglo Boer War 1899–1902, and Princess Patricia of Connaught's favourite pony, Fatima, who died 1 July 1888. The two other horses, known only as Polly and Jock, died in 1885 and 1889, respectively.

St Michael's Abbey.

Inset: Death mask of the Prince Imperial.

The Horse Cemetery.

7. Aviators, Airmen and Notable Personalities

On the ground and in the air, at home and abroad, the military heritage of Farnborough has been forged by some of the nation's most talented, bravest and daring individuals. While the achievements and contributions of some of these personalities have been commented upon in previous chapters, this chapter highlights some examples of other incredible characters associated with Farnborough.

Among their number are a flying cowboy, a Morris dancing Cold War nuclear scientist, a thrill-seeking female motor-racing champion, prisoners of war, pioneering inventors, engineers, mathematicians, aerodynamicists, aviators and airmen. Not all have wanted or achieved notoriety. Some are well known, some not so much, yet it is their lives, their stories, their achievements and their sacrifices that have made Farnborough's military heritage the diverse and amazing story that it has become.

Samuel Franklin Cody was a wild west showman, playwright, inventor and early pioneer of manned flight. Known as the 'Flying Cowboy' and 'Colonel' Cody, he was appointed Chief Instructor of Kiting in 1906 at the Balloon School, Aldershot, joining the Army Balloon Factory (ABF) at Farnborough in 1907.

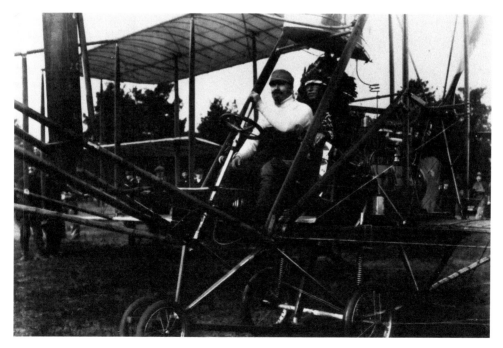

'Colonel' Cody, the flying cowboy. (AMM)

Unlike most makers of aviation history, Cody had no engineering or scientific training, and when he first became interested in aeronautics his mechanical knowledge was limited. Cody is acknowledged for his work on the large man-lifting kites, known as Cody's War-Kites, and his involvement with balloons and early airships. He is most famous for designing and building the Cody 1 biplane in 1907 and making the first recognised powered and sustained flight in the United Kingdom in 1908.

While at the ABF, Cody was instrumental in the design and testing of aircraft, engines and propellers. He achieved several aviation firsts and set many records, including winning two Michelin trophies for the longest flight on a circuit in 1910 and 1911. He died in a flying accident at Farnborough in 1913 and was buried with full military honours in Aldershot Military Cemetery. His funeral procession passed along Lynchford Road and drew an estimated crowd of 60,000–70,000 people.

Captain Sir Geoffrey de Havilland OM CBE AFC RDI FRAeS was a British aviation pioneer, test pilot and aerospace engineer who was appointed assistant designer and test pilot at the Army Aircraft Factory (AAF) in 1910. Prior to his arrival he had designed and built two aeroplanes, de Havilland 1 and 2. The first crashed, and he sold the second (in which he had taught himself to fly) to the War Office for £400. This aeroplane was renamed FE1 and became the first of the Royal Aircraft Factory (RAF) aeroplanes to bear an official RAF designation.

For the next three years, de Havilland designed and tested several experimental aircraft. FE1 was reconstructed to form the FE2, originally a fighter fitted with a central float and tested as a seaplane on Fleet Pond. In 1911 de Havilland designed a new plane for the RAF, the BE-2 which, in 1912, piloted by his brother Hereward, established a new British altitude record of 10,560 feet (3.912 metres). Following the outbreak of the First World War, the BE-2 became the standard military aircraft used by the Royal Flying Corps (RFC). The design of the plane was constantly being revised with five different versions being developed during the First World War.

Captain Sir Geoffrey de Havilland. (FAST)

Another scientist, engineer and test pilot of note was Lieutenant Edward Teshmaker Busk, a British officer in the London Electrical Engineers, Territorials. Busk was a pioneer of early aircraft design who joined the RAF on 10 June 1912 as the assistant engineer physicist. Before the invention of mechanical control devices, creating natural stability in an aircraft during flight was a vital factor. Busk researched and tested ways to make aeroplanes stable in flight without pilot intervention. In order to better understand the problems, he became a test pilot, and learnt to fly at Farnborough under the instruction of Geoffrey de Havilland.

In 1914 Busk took his theories into the air and tested them, which resulted in the creation of the RE1 (Reconnaissance Experimental) aeroplane. The machine did not rely upon one device for creating stability; it used strategically placed weights and design modifications, applied so that under almost any conditions the machine would right itself, creating the first inherently stable aeroplane. On 25 November 1913 Busk flew the machine for 7 miles using only the rudder to turn, and despite the effects of the wind, the machine remained stable in flight. This meant that during reconnaissance operations, the pilot and observer could concentrate on their primary roles of scouting, sketching and photographing from a stable platform, rather than controlling the aircraft. Busk was killed on 5 November 1914, during a test flight over Laffan's Plain (now Farnborough Airfield) when his machine burst into flames in mid-air and crashed into woodland. He was buried at Aldershot Military Cemetery with full military honours.

Major Frank Goodden started his aviation career flying balloons and airships before turning to aeroplanes. At Hendon, as a civilian, he had taken part in their flying displays. He joined

Above: Lieutenant Edward Busk. (FAST)

Right: Major Frank Goodden. (FAST)

the RAF at Farnborough as a civilian test pilot in 1914, and the RFC as a second lieutenant in 1915. He remained attached to the RAF and made a significant contribution to aircraft design. He conducted the first test flights of several aircraft, including the FE6, FE2a, SE4, BE9 and FE8. In 1916 he was appointed head of the RAF Experimental Flying Department, and later that year promoted to squadron commander with the acting rank of major.

In the late summer of 1916, the FE8 was involved in a series of spinning accidents and gained a reputation as a dangerous aircraft. To refute this, Goodden deliberately spun an FE8 three times in both directions from an altitude of 3,500 feet (1,100 metres) without incident, showing that the accidents were due to pilot error and not machine malfunction. Goodden continued to test RAF aeroplanes until January 1917, when he too was killed in a crash at Farnborough while flying a prototype SE5, which he had helped design. An inspection revealed the wings had suffered catastrophic failure from downward torsion. Goodden's funeral procession measured over half a mile. He was buried with full military honours at Aldershot Military Cemetery alongside Cody, Busk and the next aviator of note, Keith Lucas.

Captain Keith Lucas, DSc. FRS was a talented physiologist and another outstanding scientist who joined the RAF in September 1914. The aircraft of the day were only equipped with airspeed indicators and altimeters, so Lucas immediately began experimental research into aerial navigation and the use of aeroplane compasses. Through research, he discovered that errors in compass readings were being caused by small vibrations during flight. His findings lead to the development of the first stable aeroplane compass. Among his many significant contributions to aviation development Lucas developed the first gyroscopic-controlled aiming device, and, to accurately measure aircraft oscillations, he developed the 'photo-kymograph'. During this time, he joined the Territorial Unit of the RFC, and rising to the rank of captain he commanded 400 men. Like Busk, Lucas believed that to understand his research better required him to become a pilot. He believed that whatever the risk, the men doing design and research should have experience of related conditions. Lucas attended a flying course in Wiltshire in October 1916 but was killed almost immediately in a mid-air crash.

It wasn't just scientists who came to an untimely end in the air. Hermann Glauert FRS, a Yorkshireman considered internationally to be an outstanding mathematician, aerodynamicist and scientist of his day, joined the RAF in 1916 as Principal Scientific Officer. Glauert wrote many reports and papers concerning aerofoil and propeller theory, and his contribution to military aviation is well documented. His book *The Elements of Aerofoil and Airscrew Theory* is credited with being the most important instrument for distributing airfoil and wing theory around the world. In 1928, he developed a mathematical technique from existing aerodynamic theory that solved particular airflow problems; his findings were published in the Royal Aeronautical Society journal.

Glauert died in a freak accident on 4 August 1934, when he was killed by Royal Engineers blasting tree stumps to extend the flying area at Laffan's Plain. Standing at what was believed to be a safe distance, he was struck by debris. He is buried in Ship Lane Cemetery in Farnborough with his wife Muriel Glauert MA, BSc, a distinguished Royal Aeronautical Establishment (RAE) mathematician and aerodynamicist. Her first publication looked at theoretical streamlines around a Joukowsky aerofoil, while the second considered 'Two-Dimensional Aerofoil Theory'.

While at the RAE Muriel Glauert was a friend of pioneering aeronautical engineer Frances Beatrice Bradfield OBE BA FRAeS. Known to her team as 'FB', she became the first woman directly recruited to the RAE, when she responded to an advert for women technical staff in 1918. Bradfield specialised in wind tunnel research and her work was so exceptional that in 1935 she was put onto the male pay grade, which she kept throughout her career. She was a prolific writer; her earliest published research was on the 'Wind channel test of Bristol Pullman Body' in 1919, and for over a decade she published two research papers a year.

She became Head of Wind Tunnels in 1934, and in 1939 presented a paper to the Royal Aeronautical Society on the 'Use of Model Data in Aeroplane Design'. The same year she became the Senior Scientific Officer at the RAE. She was awarded the Royal Aeronautical Society's Bronze Medal in 1948; to date no woman has been awarded silver or gold medals. Her talents were not confined to science and she was renowned at the RAE for her ability in putting young scientists into groups when she thought romance might blossom.

Bradfield also worked alongside Beatrice (Tilly) Shilling OBE PhD MSc CEng, who was a British aeronautical engineer and amateur motorcycle and car racing champion. During the early aerial combats in the Battles for France and Battle of Britain in 1940, it became clear that the Rolls-Royce Merlin-powered fighters, particularly the Spitfire and Hurricane, had a serious problem with their carburettors while performing particular manoeuvres in combat.

When these aeroplanes performed a negative 'G' manoeuvre (pitching the nose hard down), fuel was forced upwards to the top of the float chamber of the carburettor rather than into the engine, leading to a momentary loss of power. If the negative 'G' continued, the fuel would collect in the top of the float chamber, forcing the float to the floor of the chamber. This would in turn open the needle valve to maximum, flooding the carburettor with fuel and drowning the engine with an over-rich mixture, which would cause it to lose power or, in the worst case, shut down completely, a major drawback in combat.

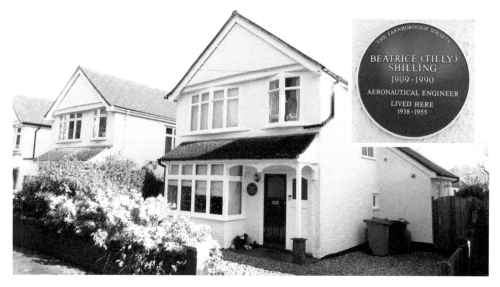

Miss 'Tilly' Shilling's home, Ashley Road.

German fighters used the Daimler Benz DB601 type fuel-injected engine and did not have this problem. In combat, they evaded RAF fighters by flying negative 'G' manoeuvres that could not be easily followed. The German pilots could exploit this by pitching steeply forward while pushing the throttle wide open, causing the pursuing British aircraft to be left flat-footed as attempting the manoeuvre resulted in loss of power, or fuel flooding and engine shutdown. The British countermeasure was a half roll so the aircraft would only be subjected to positive 'G' as they followed German aircraft into a dive, during which the enemy would escape or, if being attacked made them a 'sitting duck'.

Beatrice Shilling solved the problem by inventing a cost-effective fuel flow restrictor device known as 'Miss Shillings Orifice'. This was a brass thimble with a hole in the middle that restricted fuel flow to the carburettor.These could be fitted into carburettors without taking the aircraft out of service. A blue plaque acknowledging her achievements was erected on her house in Ashley Road, and in the town national restaurant chain Wetherspoons named a pub after her.

Between 1945 and 1947, Britain started Operation Surgeon, a post-war programme to exploit German aeronautics for British benefit, while denying the Soviet Union access to Germany's technical and scientific workforce. During the summer of 1945, German scientists, referred to as 'VIP visitors', who had originally been prisoners of war, arrived at the RAE and were interrogated to establish if their skills, experience, expertise and knowledge would be of interest to the RAE. By the autumn many of these scientists had been returned to Germany and freed.

However, many offered their services to Britain and other countries. One hundred worked for the UK, and expertise included guided-missile systems, rocket engines, aerodynamicists, flutter analysts, instrumentation engineering, servomechanisms, control guidance and gas turbines. Fifty scientists with these skills were offered contracts with the RAE.

In 1946, Muriel Glauert was joined by German scientists Johanna Weber, a mathematician and aerodynamicist, and Dietrich Kuchemann CBE FRS FRAeS, an aerodynamicist, who during the war had been researching jet engine intakes, making important contributions to the advancement of high-speed flight. Both had been working at the Aerodynamics Research Institute in Gottingen, Germany, during the war, researching wind tunnel corrections and had worked out a consistent theory of

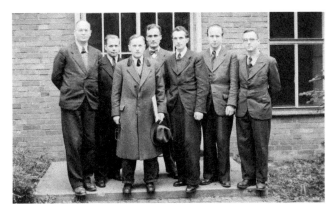

Group of German scientists at the RAE, 1945. (FAST)

flow around an aircraft. They continued their research at the RAE along with German aerospace engineers Drs Adolf Busemann and Karl Doetsch, both influential pioneers in aerodynamics and considered the foremost experts in the world on swept wings and supersonic airflow. Busemann's research into plasma physics, aerodynamics, and the theory of shock waves laid the foundations for supersonic flight and swept wing aircraft design. Doetsch, working in the same field, became head of the RAE's Controls Division, where he was involved in the development of Concorde.

Air Commodore Sir Frank Whittle OM KBE CB FRS FRAeS, inventor of the turbojet engine, received a knighthood for his contribution to aviation in developing the whittle Jet engine, which was tested at the Pyestock site. Whittle's first attempts to join the RAF failed due to his lack of height, but on his third attempt he was accepted as an apprentice in 1923. He trained as an aircraft apprentice, and then as an aircraft mechanic, qualifying as a pilot officer in 1928. As a cadet Whittle wrote a thesis that argued that for planes to achieve long ranges and high speeds, they would need to fly at high altitudes, where air resistance is much lower. As piston engines and propellers alone were unsuitable for this purpose,

Frank Whittle's Jet engine, Fast Museum.

Model Gloster E28/39, Frank Whittle roundabout.

he determined that rocket propulsion or gas turbines would be required. The first British aircraft fitted with a Whittle W1 jet engine was the Gloster E28/39, which first flew in 1941. This led to the development of the Gloster Meteor, the first British military jet aircraft. Acknowledging this achievement, a full-scale model of the E28 /39 has been erected outside the northern boundary of Farnborough Airfield on the Frank Whittle roundabout.

Another eminent defence scientist at the RAE was Henry Wilson MBE FRAeS. Wilson was Superintendent at the Guidance and Control Division Guided Weapons Department 1947–49, and Head of Armament Department 1949–56. His research helped in the development of a series of guided missiles, 'Fireflash', the UK's first air-to-air guided missile, and 'Sea Slug', the UK's first surface-to-air missile. The latter, along with subsequent generations of guided missiles, led to the development of the Cruise Missile.

During the Cold War, Britain's Chief Missile Scientist was aeronautical engineer and aviation pioneer Roy Leonard Dommett CBE. Dommett worked at the RAE and its successors between 1953 and 2000 and was responsible for the development of space rockets, as well as Britain's nuclear deterrent during the Cold War. Among the projects he developed were the Blue Streak intermediate-range ballistic missile, and the Black Knight/Black Arrow satellite carrier rocket, a rocket-propelled vehicle used to carry a missile from earth's surface into space. He worked on the submarine-launched Polaris and Trident nuclear missiles.

In 1991 he received the Royal Aeronautical Society Silver Medal and was made Commander of the Order of the British Empire (CBE) for his pioneering research and developmental work. The British Rocketry Oral History Programme awarded him a special 'lifetime achievement' in 2004. Besides being honoured for his groundbreaking scientific research, Dommett was a morrisdancer and a leading figure in English morris dancing.

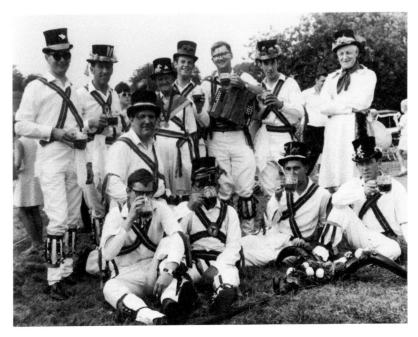

Third from left, centre, Roy Leonard Dommett CBE.

He toured the country dancing, playing music and lecturing on its history, traditions, and techniques, and supported the growth of women's morris dancing. At a tribute paid to him following his death he was accredited with famously saying 'that women were going to dance and since they wouldn't be stopped, then they should be taught how to do it well'. Roy Dommett also wrote several books on the history of morris dancing, founding Farnborough Morris in 1954. He was also involved locally with Fleet Morris.

In 1965, the Army Personnel Research Establishment (APRE) was formed at the Queens Gate site of Farnborough to carry out research into aspects of warfare applied to creating and maintaining an efficient fighting soldier. Its work included research into the ergonomics of weapons, environmental effects on humans, nutrition, clothing, personnel selection and recruit training techniques. Among their team was an unassuming quiet man, Alexander Cassie. Cassie, a bomber pilot with the Royal Air Force during the Second World War, was shot down after attacking a submarine in the Bay of Biscay in 1942. He and his crew were picked up by French fishermen and turned over to the German authorities. Cassie was sent to the officer-only prisoner of war camp Stalag Luft III, Sagan, Germany. There he took part in one of the most famous events of the war, daubed by historians as the 'Great Escape'. He was one of six forgers who produced documentation for the 200 prisoners selected to escape. Being claustrophobic, he gave up his place in the tunnel and remained behind.

Among those who escaped was Farnborough-born Tony Hayter. Hayter, a bomber pilot, had been shot down over Sicily in 1942. Having escaped, Hayter's plan was to travel by train to France posing as a Danish businessman. After ten days at large he was stopped; an examination of his papers revealed minor flaws and he was arrested. On his way back to Sagan, he was executed on the roadside 1 mile from Natzweiler concentration camp where his body was cremated. Of the seventy-six who escaped, seventy-three were recaptured, and fifty were illegally executed. After the war Cassie joined the Ministry of Defence as a psychologist and in 1965, he joined the APRE. When he retired in 1976, he was the Senior Principal Psychologist.

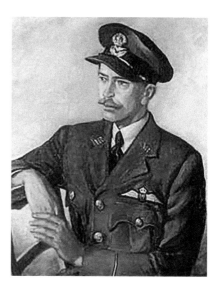

Flight Lieutenant Cassie.

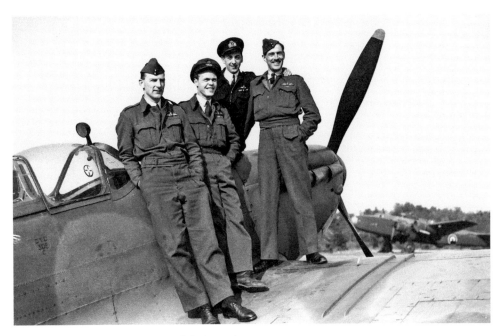

Captain Winkle Brown, third from left. (FAST)

Eric Melrose 'Winkle' Brown CBE DSC AFC Hon FRAeS RN, considered Britain's greatest test pilot, was posted to the RAE where he worked in the Aerodynamics Flight Department as a test pilot. During his time at the RAE he set many military records and achieved many great feats. As a test pilot, Brown flew 487 types of aircraft, more than any pilot in aviation history. He made a record 2,407 aircraft carrier landings and became the most decorated pilot in the Fleet Air Arm (FAA).

In 1940 Brown took part in the Battle of Britain, flying a Gladiator biplane, and in 1942 was posted to the RAE where he joined the aerodynamics department's flight division where he remained until 1949. In 1944, as chief naval test pilot, he was flying, on average, seven different aircraft a day.

In 1945 he became the first FAA pilot to fly a jet, and to land one on an aircraft carrier. After the Second World War, Brown commanded the 'Enemy Aircraft Flight' from Farnborough, an elite group of test pilots who flew captured German and Italian aircraft. Among those he flew were the Messerschmitt Me 262, Arado Ar 234 and Heinkel He 162. Although he never achieved the celebrity status gained by many of his contemporaries during the 1940s and 1950s, his extraordinary skill, versatility and courage transformed aviation.

There are many more notable personalities associated with Farnborough who have contributed to the creation of its military heritage. Their stories are as impressive as they are extraordinary and while they do not appear in this publication, it is hoped that other publications, local historians, the general public and those who work to safeguard the heritage of Farnborough will continue to preserve, protect and promote them in as many ways as possible.

Acknowledgements

In finding the primary sources needed to research the subject matter of this publication, I am thankful to the many wonderful and like-minded people I have met along the way, whose help, guidance and support have proved invaluable. I am thankful to: Hampshire Cultural Trust, the staff of the Aldershot Military Museum, the staff of the Farnborough Air Sciences Trust and the Farnborough Air Sciences Museum, staff of the Salesian College, the staff at St Michael's Abbey, the Airborne Assault Museum and Paradata.com, the Hampshire County Council Library Services, and members of the Rushmoor Writers, without whom it would not have been possible to complete this project.

For allowing access to their archives and the use of their images I am very much obliged to: the Aldershot Military Museum (AMM), Farnborough Air Sciences Trust Museum (FAST), the Airborne Assault Museum (AAM), Mr Hugh Williams (HW), Healey Newson (HN) and St Michael's Abbey (SMA). All other pictures are from the author's collection.

Mention in Dispatches: I offer special thanks for their enthusiastic support and much-needed help to Dr Graham Rood (FAST); the Revd Ian C. Hedges (St Mark's Church); Mr Nicholas Crean, Deputy Head, Salesian College; Mrs Carole Byrne, Executive Assistant, Salesian College; Mr Hugh Williams; Mrs Carol Knight; Dom Cuthbert Brogan (Farnborough Abbey); Mike Dommett; and Roger Panter.

Also, to my wife, Maria Hollands, for her endurance, understanding and patience, and to Cathrine Milne, and S. Thomson-Hillis for their critical assessment, guidance and for being able to turn my 'word salad' into something coherent and meaningful.

I also remain eternally grateful to Amberley Publishing for providing the opportunities and support to make my ambitions a reality, thank you.

About the Author

Dean has been interested in military history from a young age, and at sixteen followed his father, grandfather and great-grandfather in joining the army. He served with the Royal Army Ordnance Corps for eight years as a Supply Specialist and Physical Training Instructor in the UK, West Germany and the Falkland Islands, attaining the rank of Corporal, following which he joined Surrey Police, retiring as a Detective Chief Inspector in 2015 after twenty-six years' service.

A member of the Battlefield Trust, Guild of Battlefield Guides, and the Western Front Association, Dean regularly conducts battlefield tours in the UK and across Europe. He also acts as a guide for the Commonwealth War Graves Commission at Brookwood Military Cemetery, and for the Brookwood Cemetery Society. When not guiding he undertakes local history walks and talks and is a long-standing volunteer at Aldershot Military Museum.

In addition, Dean lectures at colleges and universities, being regularly invited to speak at national and international conferences. He is also a consultant to the New Jersey State Association of Chiefs of Police (NJSACOP) and delivers their annual European battlefield staff ride programme.